THE ARTIST'S GUIDE TO SIDEWALK EXHIBITING

THE ARTIST'S GUIDE TO
SIDEWALK EXHIBITING

BY CLAIRE V. DORST

WATSON-GUPTILL PUBLICATIONS, NEW YORK

To Mary

Copyright © 1980 by Watson-Guptill Publications

First published 1980 in New York by Watson-Guptill Publications,
a division of Billboard Publications, Inc.,
1515 Broadway, New York, N.Y. 10036

Library of Congress Cataloging in Publication Data

Dorst, Claire V
 The artist's guide to sidewalk exhibiting.

 1. Sidewalk art exhibitions—United States.
2. Art—United States—Marketing. I. Title.
N8665.D67 706'.8'8 80–20614
ISBN 0–8230–0329–9

Manufactured in U.S.A.

First Printing, 1980

ACKNOWLEDGMENTS

My thanks to my wife, Mary, for her support and willingness to look at unmowed lawns and uncleaned swimming pools while I labored over this book.

Thanks, also, to my son, Neal, for his photographs; to my typist, Susie Esposito; to Janet Park and Florence Galt, who pinch-hit in that category to help me meet deadlines; to Wayne Sessions, for his succinct comments on the original draft; and to Dorothy Spencer and Betty Vera of Watson-Guptill for their enthusiasm and for correcting my less-than-clear prose.

A special thanks to the twenty-five organizations who distributed my questionnaire and the close to nine hundred artists who answered it. Without the background material they furnished, this book would not have been possible.

CONTENTS

INTRODUCTION

Many years ago I sat on the street attempting to sell my artwork in Chicago's Old Town Art Show. I had arrived at this point after some soul searching, and with a nagging feeling of having sold out.

Holding three college and university degrees, I had taught for twelve years and practiced art for sixteen. My source of concern was the traditional belief that artists should suffer and even starve for their art. Implicit throughout all of my training had been the elitist belief that in art, rewards come only to those who remain untainted by commercialism. Art, in the grand scheme of things, is to be sold by galleries or agents, leaving the artist free to pursue his muse unhampered by outside forces. I had played this game with fidelity until my basement couldn't hold any more "undiscovered" work and my teacher's salary could no longer stand the strain of supporting me and buying art materials. I had sought discovery as an artist by the conventional means of entering and being accepted in competitions. I had mounted one- and two-man shows, picking up the costs for some. I had sent works to invitationals whenever asked and had sought gallery representation with mild success. All of this activity and effort had done nothing to put food on the table, nor did I find myself closer to the goal most serious artists seek: representation by a major New York gallery.

I wish I could report that at Chicago, my first street show, I took the grand prize and was an instant success. However, since I'm dealing with fact, not fiction, I must admit that the judge never got within two blocks of my display and all my sales money went to pay for gas, take my wife and kids to a hamburger joint, and pick up a few six-packs. The show was by no means a sellout for me, but in comparison to some of my gallery shows it was a whopping success because I did come out in the black.

Although my sales were modest, I had the good fortune of being placed next to a Japanese artist who sold fifty paintings. It was a startling revelation to me that an individual could sell $4,000 worth of art on the street in one weekend. Another of the exhibitors and I fell to discussing his good fortune. This exhibitor had just received her Master of Fine Arts degree, and her thesis show hung on her display rack. She hadn't made a single sale of her rather large, high-priced abstracts, and we sadly concluded that

it was impossible to sell good art on the street. Her father, a businessman, said we had missed the point. "You're a fool," he told his daughter, "if you ever take *these* paintings out on the street again. This gentleman [indicating the Japanese artist] should teach you the lesson that good art by itself isn't enough; it has to be good art that somebody else wants." A sobering thought, and one of my first lessons in the reality of street selling.

Since my Chicago experience I've attended countless sidewalk shows and experienced the whole range of emotions from pure exultation after winning first prize and selling very well to the humiliation of being ignored by the judges and registering an absolute zero in sales. Throughout all of my experiences, I have observed that, regardless of quality, some artists consistently sell better than others. This realization prompted me to seek an answer to the question: What makes for success in selling your art at sidewalk or mall shows?

Thus, a few years ago I embarked on a survey which consisted of 50 questions to be answered by artist-participants at shows. Of the thousands of questionnaires sent out to 60 shows across the nation, I received a return of over 850 from 25 different shows. I did a percentage breakdown of the results for all artists participating, as well as a separate breakdown for the 3 percent who had noted that their sales exceeded $2,700 per show. I did this second breakdown to discover what the big seller may emphasize that the average artist does not.

My original intent was simply to publish the survey's results and send a copy to anyone who was interested. I found, however, that the expenses involved in compiling, printing, mailing, and shipping the survey were such that I needed to seek another way to distribute the survey's information, one that would allow me to recoup my investment. Thus, the idea for this book was born.

All percentages quoted in the book are taken from the survey. I've expanded on the results so that the book can benefit not only those already experienced in art fairs but also neophites who wish to enter this fascinating and exciting sales avenue. If you are already a participating artist, I'm sure that some facts in the book will substantiate your current beliefs about artist-participant shows, while other facts will be totally opposite what you thought was true. In any case, I hope that you will benefit significantly from the information contained in this book.

1

ADVANTAGES OF ART-FAIR PARTICIPATION

In my considerable years as an artist, I have traveled many roads. I've taught at the college and university level for over a quarter of a century, served as a demonstrator for a nationally known art supplier, participated in and judged countless competitive art shows, and shown my own work at art fairs. Throughout these various opportunities for observing the art scene in this country, I have been amazed and somewhat distressed by the naiveté of artists in America.

I know scores of extremely talented artists who may be doomed to oblivion because they are trying to market their art in an outdated manner. They have failed to assay the marketplace in the light of changing times and have therefore opted for dead-end jobs to support themselves and their art while continuing to seek gallery affiliations that will, theoretically, rocket them to the big time. It can happen, but the odds against winning mention in the art history books are astronomical. History books aside, your chances of making it big in New York, a prerequisite to historical mention, aren't much better.

The competition in the Big Apple is so fierce that unless you want to pull up stakes, move to New York City, and pit yourself against thousands of other talented people who are existing marginally there, your chances of succeeding by this route are very slight. Too often an alternative route is recommended to the out-of-towner: make it big in competitive shows in your own area, and someone will recognize and reward your talent with a New York showing. Baloney! New York gallery directors rarely beat the bushes in Pumpkin Center, or even Omaha, seeking new talent. There is too much talent equal to yours readily available in New York. Remember that the viewing audiences at regional salon shows are generally restricted to residents of those areas. Such shows are not, therefore, the step into the big time that many artists take them for.

For the average artist, gallery affiliations are hard to come by no matter how great his or her talent may be. The big money in art goes to a select few high-profile living artists, with even bigger money being made on re-sales of work by historically secure, deceased artists. Galleries have to pay

the rent, and so whenever possible they will feature artists of national repute over the local talent. Most of us do not have the financial backing or the leisure to play the gallery game, nor can we wait for posterity to judge and reward our efforts. What we need is to make a living from our art today.

Where then is your marketplace? To steal a line from an old Al Jolson song, "It's right in your own backyard." Americans have become exceedingly affluent and are spending their money on art and crafts to an extent I would not have credited twenty years ago. By the conservative estimate of my survey, Americans spend over $330 million on art annually via the street marketplace.

There are two reasons for the phenomenal growth of the street marketplace. First, centers for art and art training exploded right after World War II. The regionalist art of the prewar period was replaced with an international art ushered in by Abstract Expressionism. Colleges and universities which had theretofore taught only the traditional approach to art were forced to update their approaches and offerings—and so they hired artists from the national and international art centers as teachers. Their students, in turn, became teachers; and within a decade the quality of art in the nation had improved significantly. Tired media that hadn't changed in years were vitalized by this new surge of interest in the arts. Printmaking, sculpture, and the crafts became exciting areas for exploration, and new materials found their way into the artist's toolbox. Without realizing it, we were in a renaissance. As thousands of students poured out of these new or revitalized training centers, art production increased. Galleries didn't expand proportionately, however, and so many new artists had to seek a different marketplace.

The second reason for the growth of the street show is postwar affluence. After years of self-denial, people were making money and spending it as fast as they made it. It's only natural that affluence and the increase in production would find a meeting ground, which was offered by the street and shopping-mall art fairs.

More Americans are ready to spend from $10 to $200 or more on art than there are major collectors with $1,000 for the same purpose. If you have priced your product reasonably and are willing to work on presentation and sales, there is no reason why part of the annual $330 million street-art outlay can't be yours. Furthermore, I believe that the time is not far off when the art-fair marketplace will be recognized for its contribution to the national art scene. There are already countless highly talented artists marketing their wares on the street, and I've seen museums and collectors buy from these artists at figures around $4,000. Street art is already

a force in the art industry, and those artists who dismiss its impact, both immediate and potential, are making a grave mistake. Street exhibits are already being audited to keep artists informed of the shows' quality, and I foresee a time when artists will be given reviews based on work shown at art fairs.

AVENUES FOR MARKETING YOUR ART

Being a child of the Great Depression, I've been conditioned never to let pass an opportunity or a dollar. Consequently, when I embarked on a career as an artist I pursued all avenues, both conventional and unconventional, to place my paintings before the general public in the hope of finding a permanent marketplace. I've hung one-man shows in banks, bookstores, churches, and libraries, and in more restaurants than you'll find in Gary, Indiana. In addition, I've had paintings auctioned off by charities on a percentage basis. I've hung work in rental-sales galleries, where a rental customer can later decide to buy, with his rental fee applied against the purchase price. I've also exhibited in regular galleries.

How successful were these ventures? With a few exceptions, I no longer hang one-man shows in public places, having found such shows to be financially losing propositions. I seldom recoup through sales the initial framing costs of that kind of show. I don't want to discourage you from availing yourself of any opportunities you may care to try, but the point is that for an equal effort, the chances of selling your work are much greater at an art fair than at this sort of public outlet.

I have fared slightly better at charity auctions, where a percentage of the sale price goes to the artist, but outlets of this type are few and therefore cannot offer a steady source of revenue. A rental-sales gallery, which is usually run in conjunction with a museum, can be counted on for a few dollars; if you have a mass of work available you might try leaving some at outlets of this type. One did quite well for me in sales over a three-year period.

I should point out that, at a rental gallery, your work will be tied up for a contracted period of time (usually a year) during which it is unavailable to you. I can recall trying to retrieve one painting from a rental gallery for a full year *after* the contract had expired, only to find it on continual rental and therefore not available. Also, you will be periodically requested to remove work that has proved unmarketable and replace it with new work. This can be a drain on your time without sufficient returns.

In competitive or salon shows, you submit either slides of your work or the work itself for possible inclusion in a show which will be hung for a stated period of time—usually, but not always, at a museum. Salon shows

are great for the ego and prestige but are not a reliable source of income. If you're new at the game and are seeking public recognition plus fodder for your promotional material, such shows can serve that purpose. Some entry blanks for sidewalk shows provide space for mention of your most recent awards, and an award may be a consideration in your acceptance into a show.

Bear in mind also that competitive shows are just that—competitive. Where art fairs have increased a hundredfold in the past ten years, competitive shows have decreased in number; and those that are held are usually deluged with entries because of the role they have traditionally played in the artist's bid for recognition. One of the few remaining prestigious national shows had 1,500 entries in 1978. Four prizes were awarded. Artists were allowed two entries, which meant that at least 750 artists had framed and either shipped or hand-transported work to the show and paid an entry fee. As 60 entries were chosen to be hung, each artist had 1 chance in 12 of being selected, and 1 in 187 of receiving an award—odds that offer only a very slight chance of being financially rewarded for your efforts. Although some work is occasionally sold from competitive shows, sales are few because of the esoteric quality and usually high price of the work displayed. In all of my years of competitive showing I've sold only two works at these shows, although some of my paintings have won prizes. The publicity or career value of competitive shows resides solely in the artist's *vita* and rarely reaches significant patrons unless they see the exhibits.

THE GALLERY VS. THE STREET

Many artists, I'm sure, would place street selling second to an affiliation with a legitimate gallery that could handle their entire output and provide them with a fair return on their investment. Realistically, this avenue for marketing your work is not easy to arrive at. Statements by artists indicate a general disillusionment with art galleries that parallels my own, which was a factor in my first going to the street with my work.

Let's face it. Operating an art gallery is a tough way to make a living, and the people who do it are all too often without knowledge of art or how to market it. They fantasize spending their days sitting in a well-appointed, air-conditioned room with a rug on the floor and spotlighting on the ceiling; they envision on the walls the work of young undiscovered artists with the potential of making both themselves and the artists rich. This dream lasts until the end of the first month, when the bills come due and there is nothing in the till with which to pay them. It's then that they ruefully recall the potential customer who came in a week ago Tuesday and

requested a large floral in soft yellows and greens; so, to stay in business, they gradually abandon their high hope of selling great art and attempt to answer the public's demand for less ambitious works. It isn't long before they start selling "European imports" because of the higher profit potential. Meanwhile, the original artists' work has been shoved into a storeroom out of view, and any profit from the sale of such work has gone to meet current expenses. Many galleries suffer this downward slide; go bankrupt, tying up the artists' work in legal entanglements; or simply vanish without a trace of themselves or the artwork.

A pessimistic view? Perhaps, but of the ten or so galleries that started in my hometown in the last dozen years, seven have met this fate. Two survive by selling art supplies, and only one can be called a true gallery. Let's contrast, from the artist's point of view, the differences between the two methods of marketing your art: the gallery and the art fair.

Most galleries take from one-third to one-half of the sales price of your art, depending on how much they put into your promotion. If you're in their stable of artists, and are given one-man shows complete with promotion and openings, they take half. If, however, they simply have your work on consignment without the peripheral costs, they should, but do not always, accept a third. To allow for the gallery's percentage, you can either raise the price of your product or take less for your work. You usually bear the added expense of delivery and pickup, because most galleries want to change their offerings periodically to get rid of unmarketable objects and try something new. In addition, some artists who sell through galleries have found that money from sales is often held for months by the gallery in an effort to keep its books in the black. Artists have had to be quite persistent to get the amount due them in a reasonable period of time. This is a characteristic not by any means limited to small regional galleries.

If you are included in a gallery's stable of artists, you are usually afforded a three- to four-week solo show every few years. The rest of the year your work may be available but not featured, or it may be crammed into a storeroom where it will be seen only by the mice or by someone who makes a special request. In addition, galleries suffer from the stigma of exclusivity. Many people who are interested in purchasing art shy away from entering a gallery because they fear that prices are outrageous, and that to inquire about price will be embarrassing. A worse fear is that they will be backed into a corner by some supersalesperson who will pressure them into a purchase they neither want nor can afford. Such galleries do indeed exist, but fortunately they are few. However undeserved the stigma of exclusivity, it does deter buyers. Unsophisticated people equate galleries with museums, treating them as solely educational institutions

and ignoring the fact that they're retail outlets.

As an artist selling on the street you get 100 percent of all sales; this means you can afford to sell for less than you would in a gallery. You may argue that price is not a consideration for the buyer of art, but you will have trouble convincing me of that. I sell twice as many $7 prints as $15 prints, and five times as many $15 prints as $30 prints. You do have to pay "rent" in terms of an entry fee; my fees averaged $45 per show last year plus the usual $5 nonreturnable jury fee per show. (A jury fee is the payment made for the privilege of having your work screened by a committee to decide its suitability for inclusion in a show.)

At a street show, you must also consider meals and lodging while you are there, but if this expense is a problem you are in a position to adjust your living standards as necessary. You can always sleep in your van and carry sandwiches from home. Some artists borrow floor space in the homes of local artists for their sleeping bags, reciprocating when the show is in their locality. The only other additional expense is gas for your vehicle.

At a major art fair, more people are going to view your work in one afternoon than would see it in a year of gallery exposure. The more shows you enter, the greater your opportunity to show and sell. My sales in one three-day sidewalk show in 1978 exceeded my returns from four galleries that had my work on display for the previous year.

There is nothing pretentious or phony about an art fair; your presence is understood by everyone. You are there for just one reason: to market your wares. The customers are face to face with the creator of the work on view and can question the artist directly if they wish. With price tags visible on the work, there is no need to wonder about its affordability. The customer will not feel trapped, as in a gallery, because most shows are held in an open space; escape is as simple as turning and walking away. Consequently, the whole atmosphere on the street is without the pressure or apprehension that can inhibit purchasers in a gallery.

In a gallery your work is tied up for a stated period of time, and its exposure is at the discretion of the gallery operator. This prohibits your entering this work in competitive shows or negotiating privately for its sale without cutting the gallery in for a percentage. Because of the short tenure of many galleries, it's possible for them to close without your knowledge and abscond with your work. It has happened to me. There is also another hazard. Although you are aware of the small print in your contract that absolves the gallery of losses due to theft or fire, you ignore it to build good will with the fledgling gallery against the time when it becomes a force in

the industry. That posture lost me $650 in thefts from a gallery one year, and it was *not tax-deductible*!

Considering all these laments, you're wondering if anything has ever gone right with me in my gallery relationships. In fairness, I have to say yes. I've shown in galleries that, although they didn't make me rich or famous, at least didn't steal from me, which puts them on the plus side. Some galleries have promoted me, looked after my interests, and sold modestly well; but these, unfortunately, I can count on my thumbs. Not only do you lose physical control of your work in a gallery situation, but you can also lose esthetic control. If a gallery has promoted you as the foremost painter of bluebirds, they don't want to see horses even if your muse is whispering "horse" in your ear. I can appreciate the gallery's concern for its investment; however, as a result—though your contract may not state it in writing—you are under pressure to give the gallery what it wants.

In street sales you have total control over your work, and you can be as wise or as foolish with this responsibility as you care to be. You can show it or not, you can trade it, bargain-price it, raise prices, or give it away. You are likewise your own captain regarding the direction you care to take in your work, answering to no one except your customers.

In a long-established legitimate gallery you have an immediate dollar value based on the gallery's reputation as well as the prices commanded by the work of the other artists they represent. Less established galleries may be featuring an artist with a national or international reputation in their main area; but to pay the rent they may handle, in the back room, work by locals who are proven sellers. Those rare galleries that really work at selling can usually realize more for your work than you can. This advantage is immaterial, however, if they sell one piece of your work a year for $1,000 and take half in commissions, while you sell ten pieces on the street for $350 each.

If you are fortunate enough to be a featured artist in one or more galleries, you might be in the enviable position of having your entire production accommodated. However, if you are on consignment, the gallery will in all probability be unable to handle your entire output. Serious artists are productive artists, and you can't make a living from occasional sales.

Except for repeat customers and referrals, most sidewalk sales have to be made from "cold" contacts, because there is not the preselling through promotions and publicity that you find in gallery representation. This is a distinct disadvantage if your confidence isn't the greatest; you have to work at inspiring immediate faith on the part of the customer in both you

and your product. How this is to be accomplished will be discussed in a later chapter.

START AT THE TOP

There is one aspect of marketing your art on the street that I consider a true phenomenon. I know of no other activity that allows you to plug in at your current level of accomplishment without the traditional dues-paying that is most often a necessity for advancement in other careers.

You can start at the top immediately, if your ability places you there. This is not true of gallery representation, where the accepted procedure is to become known through competitive exhibitions, invitationals, etc., for a respectable number of years and to achieve a sufficient reputation in a certain style to interest the gallery in representing you.

In street selling, if your product is of the highest quality and you have the price of entry, you will be given equal consideration with those who have established solid reputations. Screening committees don't care if you're black, white, or green; if you're male or female; if you're eighteen or eighty; if you've been an artist for two or twenty years; or if your *vita* is one sentence or ten pages long. Their concern is the merit of your work.

This aspect could be a problem for older artists who hope to rest on past accomplishments instead of keeping up with current styles. In street selling, you are forced to assess your product constantly in terms of today's art and to upgrade your product continually if you hope to stay among those who are accepted into shows. You've got to think young no matter what your numerical age may be.

A FRESH START

One of the fascinating aspects of art-fair participation is that you can, in a brief period of time, turn a dismal sales record into an enviable one. You are the only one responsible for the promotion of your efforts; consequently, you're under no obligation to stay with a product that has proved unsaleable or only marginally successful. As you analyze your sales, you will be able to recognize which images, colors, shapes, or whatever outsell others. If you capitalize on these discoveries and produce more work in the acceptable vein, sales will most likely increase.

Unlike gallery representation, where you are locked into a style for at least a year and perhaps longer, in street selling you can change the entire complexion of your offerings in a few short weeks or months. Because your viewing audience changes from show to show, few persons are monitoring your work; even in repeat shows a majority of the viewers will be new and therefore will not associate you with a specific style or medium. If your changes are successful, even old customers and acquaintances will

react positively toward your improved product.

Returning from a show is always a time of reflection. If a show went well, you consider the reasons for your success; if it went badly, you try to discover where you went wrong. Returning from a show one year, I engaged in just such soul searching. The show was a major one and, as my expectations hadn't been realized, I was trying to determine my errors. I had taken some huge 4-x-5-ft (1.2-x-1.5-m) abstract paintings to the show, hoping for customers with large walls and fat checkbooks. Although a few had surfaced, none had bought. The only pieces I sold were prints out of my portfolio. Although the paintings were of high quality, I had to face the fact that the scale and subject matter of my paintings were limiting my audience; and, because of the effort that had gone into the work, I couldn't afford to sell at a figure within the means of the average buyer. For future work, I had two options. One was to cut scale and price, but that wouldn't resolve the limited appeal of abstract work. My other option was to go only with the figurative prints that had already proved negotiable. As my prints were small and inexpensive, I decided I should raise some of my prices to what I considered a realistic level and also produce some larger, more complex, and more expensive prints that would be good enough to compete for prizes and gain me entrance into shows. I also determined that to give this new approach a fair chance, I should attend at least five shows without making any other changes. In the next five shows I attended, I sold more than I had in ten shows the previous year, and I'd garnered three awards as opposed to one at the same point in the show season.

As my new work was selling better, winning more prizes, and receiving accolades from fellow artists whose opinions I valued, I felt my change was an auspicious one, and one I could not have made as easily if I had been marketing my work through the more conventional channels.

I can report on others whose successes were much more spectacular than mine. There was a young woman whose sales went from zero to $2,000 per show in only one month by changing her subject matter, color, and techniques. Her changes were not of a sort that lowered the quality of her product to reach a market. No self-respecting artist would ever consider such a move. But the ability to make adjustments in your work based on your observations, and to do so quickly, is truly remarkable. Every show is a new start on the road to success among those artists with enough vision and tenacity to pursue a goal.

THE ODDS ARE IN YOUR FAVOR

According to the survey, 63,450 artists and craftsmen are making their entire livelihood from participation in sidewalk and mall shows. Contrast

this with a recently published report that less than five hundred New York-based artists are able to exist solely on the sale of their work through conventional galleries.

Based on these figures, your chance of making a living from selling your art is 127 times greater if you act as your own agent at street sales than if you try the more conventional route of New York gallery representation in marketing your art.

Granted, the really big money is going to the current "name" artists on the New York scene, but I know of some street artists who take home a respectable $30–40,000 a year from their street sales. *The odds of making a living from your artistic efforts are much greater in street selling than in any other art-marketing activity presently being used in America.*

2

ARE YOU READY FOR THE STREET?

I am often approached by amateurs and students with the question: "Do you think I could sell my work at art fairs?" The fact that a student receives high grades in his courses does not mean that his product will be in demand by the general public. Likewise, amateurs are often lulled into a false sense of adequacy by the fact that parents or relatives just love their work. Neither of these phenomena is necessarily negative, but by itself is a weak indicator of success on the art-fair circuit. Failure to evaluate your readiness properly can lead to some rather discouraging results, and too many frustrating experiences can turn you off completely.

Before you try to sell your own work in street shows, consider these questions: Is your training adequate? Are you willing to improve your product continually and orient it to the marketplace? Do you possess the stamina and patience necessary to deal with the public? Are you willing to develop the business sense necessary to achieve success? These questions will help you determine your readiness for art fairs.

IS YOUR ART TRAINING ADEQUATE?

Approximately half the fair-artists represented in my survey had formal instruction at art schools, colleges, or universities. Another fourth of the artists studied with artists or craftsmen outside degree-granting institutions. The remaining 25 percent claim to be self-taught. Of the more successful artists—the top 3 percent of the total number surveyed—31 percent hold college degrees, as opposed to 26 percent of all artists in the survey, and fewer in the most successful category claim no formal training. Some with degrees in art have never studied in their present area of specialization, and others hold degrees in areas other than art. Since the art process involves the head as well as the hand, I suspect that the capacity for deductive reasoning developed in other disciplines helps in switching to the practice of art.

Art, because of its freedom and its lack of time clocks, is a popular choice among many people seeking second careers. It's surprising how many students I encounter who return for a degree in art after achieving

their first degree in a totally unrelated area. In today's shifting job market, many who thought they were headed for careers in fields such as teaching, social work, or business, found the doors closed when they went job-hunting; others found work in their field, but in jobs that failed to make use of their training, and so they became disillusioned. When this happened, they returned to art, which often was their first love. Admitting that to succeed in art is a struggle, they nonetheless opted for it, knowing that with hard work their efforts would pay off in a direct way—you don't have to wait for a vice-president to retire to move up the ladder of artistic success. Other than the field of popular music, there isn't any other area I can think of where overnight success is as possible as in marketing your art at street fairs. The excitement of the creative process, the expectations in show attendance, the anticipation of making the big sale, and the ability to make judgments and take decisive action result in a more rewarding existence than you will find in many "secure" forty-hour-a-week jobs.

Thirty-one percent of the street artists surveyed who had formal training thought their training was of substantial benefit to them; 44 percent indicated that it was of some benefit; and the remaining 25 percent expressed disillusionment with the training they had received and felt it was of no benefit. The more successful artists were willing to credit their success to the training they received, 40 percent of them saying it was of extreme benefit. However, there are undeniable reasons for discontent with the training heretofore available to artists, as expressed by the 25 percent.

Art schools, which offer certificates rather than degrees, have traditionally oriented their training toward developing artists capable of producing art for commercial reproduction. Although fine-arts training is usually a part of the program, it is not pursued to the same extent as in degree-granting institutions.

Colleges and universities tend to prepare artists for teaching in the public schools; follow the liberal-arts concept wherein art is part of the education of a well-rounded individual; or train artists to fill teaching positions at art schools or universities. Twenty years ago, when institutions of higher learning were growing rapidly, there was a demand for teachers; consequently, ambitious, talented art students were encouraged to go on to graduate studies and eventually teach at the college level. This is no longer true. Today, with decreasing student enrollments, most schools are holding the line on hiring new teachers. Programs in fine arts which embrace the liberal-arts concept—which developed when education was the sole prerogative of the affluent—presume the student has developed the ability to make intelligent decisions in anything he or she pursues in life. While education has been democratized through state-funded institu-

tions, the traditional training of the past century has persisted to some degree until today. There are signs of change, however, as specialization in art training is slowly being recognized. More universities offer degrees in the applied arts areas of interior design, landscape design, commercial design, etc. Many institutions which used to offer only the B.A. degree in art and demanded the fulfillment of specific requirements in language, the sciences, and humanities, have recently introduced the B.F.A. (Bachelor of Fine Arts) degree, which allows greater specialization and concentration in art and reduces or eliminates many of the outside requirements.

Although the diminished demand for college art teachers was foreseen, no institution, to my knowledge, has tailored a program to prepare the art student for a career that would allow him to make his living from doing what he most enjoys: creating and marketing art. Admittedly, such areas as printmaking and the crafts may be career preparation without the intent or realization that they are partially fulfilling a need. It is safe to say that most college and university art departments still attempt to produce students whose goal is to teach or to produce art for one of the nation's 200 or so major collectors, ignoring the more obvious and realistic marketplace available to them, that of the artist-participation show.

Being a product of liberal arts institutions, I cannot be as severe in condemning the system as some of the artists I surveyed. As a street artist, however, I am sympathetic to the plight of those who feel shortchanged in their training. Eight percent of the artists surveyed feel the current approach in art training institutions is the correct one; but another 8 percent would reverse it so that all training is oriented toward turning out the journeyman artist; and the vast majority, 84 percent, feel that training should be given in both areas, with the student permitted to decide which direction to pursue.

Perhaps it's time for a new type of institution devoted to esthetics, craftsmanship, productivity, salesmanship, and all other facets that would train artists to succeed in merchandising their art.

EXPANDING YOUR KNOWLEDGE

If you plan to stay on top in your profession, whether it be law, medicine, or art, continuous study is not only desirable, it's necessary. Where can you turn for help in upgrading your skills and, consequently, your product? One possibility is to look for the individual whose work you most admire, and arrange to study with that artist. Or you may prefer to study at an institution. Colleges and universities usually have up-to-date facilities, and they try to stay abreast of current trends. Find out who the best instructors are, and audit their classes. Auditing is preferable to matriculat-

ing as a degree-seeking student because, as a working artist, the last thing you want is to be tied to a rigidly structured class where you are forced into competition for grades. There is no value in subjecting yourself to unnecessary tensions and restrictions, nor in taking courses that are rehashes of what you already know.

Look into workshops being offered around the country that concentrate in your area of specialization. Many art specialty magazines such as *American Artist, Crafts,* and *American Craft* run ads on workshops. If you can't afford to go to a workshop, join your local art organization and run your own workshop, bringing in the instructors whom you feel have the most to offer. If you are a watercolorist, the slide-cassette workshops available at nominal fees through the American Watercolor Society are excellent instructional aids.

Books are an invaluable source of information. My own library contains in excess of 360 art books. Unfortunately, bookstore offerings in art are most often large, expensive art histories, or profiles of famous artists. Many stores do not carry an extensive selection in the "how-to" category. For this reason, I send away to publishers for most of my books.

Watson-Guptill has over 400 titles listed in its latest catalog (available from Watson-Guptill Publications, 2160 Patterson Street, Cincinnati, OH 45214). Offerings cover all phases of fine arts as well as most craft areas.

The inexpensive paperbound books sold by paint dealers are usually rather limited in content, but some are worthwhile, and I have a dozen that I couldn't resist buying.

I hesitate to give a blanket endorsement to *all* adult-education classes because they are often oriented to the hobbyist and amateur rather than the serious artist. Some excellent instructors do teach in these programs, but you'll have to be selective. Always talk to the instructor before enrolling in any course, to be sure it will fulfill your needs.

Correspondence courses are expensive and rigidly structured, and some deal solely with commercial art. Perhaps their biggest drawback is that it takes a person of high resolve to pursue them to completion, knowing that help is days away, by mail. As an artist, you don't need time-consuming exercises; you need capsulized, comprehensive information that you can assimilate and use immediately.

Perhaps one of the best means of increasing your knowledge is to talk to the more successful art-fair artists you encounter. Every show will have a prize-winner in your category. Seek his or her advice, ask questions, or ask to have your work criticized. Advice from these artists will be not only invaluable, but also free, and usually given eagerly. Those who are successful have a driving compulsion to share their understanding with less fortu-

nate artists. I discovered this a few years ago, when I was attempting to start a program in para-architecture at a university. I outlined my plan before a group of architects and asked for volunteers to speak to groups of students on what makes for success in architecture. About half of the audience volunteered. Everybody has answers; all you need are the questions.

Don't shy away from reading books or taking courses outside the art area if you need help with merchandising, display, salesmanship, or simple accounting. It is possible that a seminar in sales could significantly increase the returns on your product.

If you are already consistently winning prizes and selling up a storm, do you really need the advice I've been giving? I know of just such an artist who takes time every summer to attend a workshop; and when he is in production, he reads and rereads one particular book that he has found invaluable. He knows its contents, but he nevertheless reads it at least once a week because repetition helps keep him on the track.

WHAT YOU NEED TO BEGIN STREET SELLING

First, and most obviously, you need to have a product. I keep meeting would-be art-fair artists, particularly students, who bemoan the fact that because of their low production they are not ready to try their luck on the street. The average artist, my survey revealed, takes slightly over fifty pieces to a show and sells about 25 percent of them. I feel that with only 12 to 15 works, an artist can start a career in street selling. That number will not sustain you for long, but it's enough for a trial run. No matter how few pieces you take to your first show, be sure they display a consistency of medium, technique, style, and subject matter and are presented in a professional manner. Don't throw a lot of miscellaneous stuff at your viewers. That will turn off the judge and label you as an amateur. Buyers are interested in arrived artists, not those who are on their way. You will never be able to determine the demand for your work until you place it on the block. Who knows? You may get lucky and walk off with the top award, or sell out your complete stock. But even if you do neither, the experience you gain is not purchasable, and if you act on the knowledge acquired it could speed you on your way to your goal. It's never too early to start.

I have a recurring nightmare, especially during the show season, in which I sell out the first day of a show and am forced to sit there for two more days with empty racks, watching thousands of potential customers walk by. Perhaps the nightmare would go away except that I rarely attend a show where someone doesn't totally deplete his stock, if not in one day, then over the three days of the show.

Experience will indicate how many works you can sell and how many you should take. It's possible to transport too much, so be selective in what you haul. I know of one artist who takes out everything he has ever done to every show. Sales seldom offset his glass breakage and the abuse to his frames, to say nothing of the hours that go into setting up and taking down this mountain of work.

Abe Lincoln is credited with saying, "Only a fool makes the same mistake twice." Yet, year after year, I have seen certain artists attempting to sell the same product with the same disappointing sales results. Why they do it I have yet to figure out. Perhaps they are waiting for the pendulum of artistic taste to swing their way. Forget it. The pendulum doesn't swing; it mildly undulates, and if your art didn't sell last year the probability is that it won't sell this year or the next. The art-buying public is not suddenly going to develop a taste for what has been previously nonnegotiable.

Let me make a suggestion that may horrify you: Destroy or put away what isn't working. In painting, I have found that it's easy for the artist to become infatuated with a certain section of a painting, which may be in total conflict with the rest of the painting. There are two possible avenues to solving this problem: either destroying the beloved area or making the rest of the painting compatible with it. Many painters can't bring themselves to commit this act of destruction and consequently never finish the painting satisfactorily. The same is true of your merchandise. You can justify exhibiting a work for two years; but if by that time it hasn't found a market, give it away, destroy it, or rework it. The only exception would be a piece that has won prizes but hasn't sold because of price; in that case, keep it but remove it from circulation.

I'm against holding sales to dispose of artwork that hasn't moved—because those who have paid the full price for your product will resent your selling for less. Occasionally I have wholesaled, at some rather ridiculous prices, a van-load of work I haven't managed to move. The wholesaler usually manages to sell the work at my asking price, so I stay out of trouble with my customers.

After you have selected the works you will exhibit, certain practical matters must be considered. You will need transportation to and from the shows. Usually this is not a big problem, as most of us already have something available. I would hesitate to splurge on an expensive vehicle such as a van or truck until you've assessed the marketability of your wares. Wait until your profits and commitments make it a wise purchase. Most people with ingenuity can make do with what is already available. I have a former student who paints 8-x-8-ft (2.4-x-2.4-m) paintings and manages to carry four of these, plus his display racks, lashed to the top of his little

Volkswagen. (He does take the corners slowly.) Another artist travels to shows by Greyhound bus. I know because I once helped him haul his work from the bus depot to the show site—and then *he* carried off the prize money.

You will need stamina. The sun is hot, the wind is strong, the dust is thick, and it's bound to rain. If you drive to a show on opening day, plan on some sixteen-hour workdays. Figure on the parking facilities being three blocks from your space and your being forced to manhandle your work and display equipment that distance; on your space being blocks from the nearest Jiffy John; on the coffee vendor not setting up till noon, and an enforced ban on alcoholic beverages. If only part of these problems arise, count your blessings.

You will need to possess or develop a business sense and an ability to cope with procedures. You'll need them to figure costs, calculate profits, handle credit-card purchases, wholesale your product, build a file of your clientele, and to handle many other matters you will soon discover. Many of us became artists because we didn't want to be businessmen and now, alas, we find that to be successful we must regard art as a business.

You will need patience and the ability to see forests, not trees. Not every show is going to be a sellout or net you a first prize. I attended a show five years ago where sales were absolutely zero, and although the judge made my heart pound for five hours, I struck out in prize money as well. The experience was so devastating that it was four years before I could force myself to return to that show. On the latest try at the same show, I garnered a substantial amount in sales and prize money. You've got to be able to take an overall view of the shows and have faith in your work and your ability, or you'll go driving off the bridge after a disastrous weekend. On the other hand, an objective analysis of each particular show afterward will help you assess the merits and the practicality of returning the following year. Do this while the memory is fresh. If you wait until it is time to send in the fees for next year's show, the memory of poor sales may be obscured by a recollection of the good food and fun you experienced at that show.

If you have money to spend, there is no wiser way to spend it than in preparing your work for proper presentation and constructing a stunning display. These two areas will be covered in chapters 6 and 7.

WHAT WILL IT COST?

With inflation still on the increase, it's hard to predict where entry fees will go. Artists who were vowing three years ago to stop attending shows when the fees hit $40 have since seen fees increase by one-third. What's the al-

ternative to attending the shows? My fees averaged about $45 last year. In addition, I paid a $5 jury fee at about half of the shows I entered. Rising fee costs will make artists a bit more selective about which shows they enter. I have crossed two shows off my list where sales in the past haven't been great. I might have eliminated them anyhow, but the factor that pushed me to action was the increase in fees.

The fact still remains that shows which spend money on promotion and draw huge buying crowds are going to fill up and have waiting lists regardless of the fee. The fee of one local show hit $100 last year, and despite the expectation of exceeding that figure this year, had to turn away three times as many applicants as it accepted. Prize money in this particular show runs to $10,000, and sales are absolutely fantastic; almost everyone does well. Even shows that aren't as rewarding in terms of sales can usually fill up with artists, at average fees, if prizes are substantial enough.

The periodical *Sunshine Artists U.S.A.* has reported that some cities are requiring a city license of $10 to $15 from artists wishing to sell their work. I've never encountered this, but I understand that the fee has been levied at shopping-mall shows, although not at street shows. I also understand that some promoters assume this cost.

There are other costs that vary with the area and are difficult to project with any degree of certainty. What will gasoline cost next spring, or food, or lodging? It's possible to adjust your style of living in order to lower expenses. Many artists, myself included, carry a cooler stocked with drinks and some food to avoid the excessive prices of concessionaires at art shows. It is a wise move to plan ahead for lodging. Most motel chains will make your reservations for accommodations near the show site. Some shows will send you a list of motels in their area, with phone numbers. It is wise to reserve as soon as possible (in fact, the day you receive the information), to avoid spending the night propped against your steering wheel. "mom-and-pop" motels are usually less posh, but much, much less expensive. The difficulty is making contact. Once you've been to a locale it's a good idea to note names and addresses of some of these less expensive motels for future reference. Alternatively, as suggested earlier, you can carry a sleeping bag and borrow floor space in a local artist's house.

More and more artists have taken to camping out in their vans or recreation vehicles while attending shows. Camping fees at state- and privately owned parks are nominal, running from $4 to $10, depending on the accommodations offered. Most have showers and bathrooms. Some offer electric hookups, barbecue stands, swimming pools, and convenience stores.

Other artists of my acquaintance look on their attendance at shows as

mini-vacations and live high off the hog, staying at expensive motels and dining splendidly. These artists, needless to say, are the successful ones. As no two people have the same tastes or needs, it is impossible to predict accurate costs. It is a good idea to keep records of your costs over a year's time and then determine whether you are getting rich, breaking even, or going into the red. Advice on keeping and analyzing records in your art business is given in chapter 10.

WHAT CAN YOU EXPECT TO EARN?

Only 27 percent of art-fair artists rely on show sales for their total family income. The remaining 73 percent sell through other outlets besides fairs, hold down other jobs, or have spouses who work. Many craftspeople sell through a variety of outlets in addition to street fairs. It is interesting to note that 4 percent of the artists surveyed stated that their sales are augmented by social security checks. It's comforting to know that I'm not the only old-timer still dreaming. Those artists in the upper 3 percent of sales averaged about $2,700 per show, while among the average artists, the highest average amount earned at a single show was $650. I have no exact figure for the highest amount taken in at a show, but I know of artists who have topped $6,000 at a single weekend outing.

The average street artist does not maintain the high average figure of $650 realized at a single show, but makes about $260 per show and attends eight shows per year, thus averaging $2,080 per year from his participation in art shows. It is a safe assumption that the average artist is one whose earnings from art shows are only supplemental to his major income, and that he could not survive on the art-show money. Some only hope to make enough to pay expenses and keep themselves in art supplies, and thus be able to continue doing what they enjoy. It is my opinion that too many artists underestimate their abilities and potential, and consequently, they settle for less than they are capable of earning.

The figures cited above can be sobering if you consider yourself average in sales and expect to remain so. The purpose of this book, however, is to move you up from average earnings to a level where your return is in the thousands, not hundreds, per show. If you are already a street artist, these figures should prove enlightening, showing how well you are doing as contrasted with the average artist. One reason I undertook the survey was to find out where I stood in relation to the average artist. It is comforting to know I'm now doing better than average, but that hasn't always been true. After completing and analyzing the survey, I sat down and made some major decisions based on my findings. I took action on these decisions and made some changes in my presentation, display, product, and sales ap-

proach. As a result, during the 1978 season I doubled my sales over the high annual earnings of any previous year. Any artist, by following the suggestions in this book, should be able to do the same, and perhaps much better. I don't by any means feel I've peaked. I'll continue analyzing and changing until I hit $2,500 or more per show. The sky, I firmly believe, is the limit.

The fringe benefits from your art-fair exposure cannot be estimated. They will vary from artist to artist and from year to year. A discussion of fringe benefits appears in the next chapter.

HOW TO PRESENT YOURSELF

Perhaps no other single factor will be more significant in your success or failure as a street artist than your attitude in artist-customer relationships.

I know artists of superior ability who cannot face a potential customer in a street-selling situation. One artist found that in order to go through this ordeal, as it was to him, he had to fortify himself with so much booze that he was nonfunctional. Still others try to cover their fear with a superior and condescending attitude. Some withdraw and hide, pretending to read or sleep. None of these people, of course, survives more than a few shows. They pull out of the show scene, damning the whole industry in order to preserve their egos.

How often have you gone into a store, waited and waited for a sales clerk, and finally found one chatting with a fellow employee about last night's date and ignoring you and other customers? My reaction is to walk out of that store, vowing never to return. In contrast, when a salesperson approaches me with the smiling inquiry "May I help you?" my reaction here is to buy if I find what I want, and to return to that store because of the help offered. Customers for street art respond the same way. Smiles don't cost a thing, and as long as you have opted for showing your work to potential customers and paid a fee to do it, why not take every advantage of the opportunity?

This upbeat attitude was reflected in the survey, with 74 percent of the artists feeling positive about the whole scene and expressing no humiliation or discomfort about their participation. They said they enjoyed the personal contact with the customers, which was a prime factor in bringing them to the street. Most customers, for their part, enjoy meeting the artist face to face, and the meeting is significant in the marketing of your art. Artists should not feel superior simply because the public has not had training in the arts equal to theirs. How many artists can fix a television set or plow a straight furrow? You will be called upon to explain your art, not only to defend, but also to educate.

I can't begin to remember all the times when a friendly conversation, an

explanation of my techniques, or the discovery of a mutual interest has turned a casual looker into a purchaser. Uneasiness in a customer-seller relationship must be conquered if sidewalk selling is to be successful. As 74 percent of the more successful artists mentioned their enjoyment of the customer-artist contact, it would seem that liking people is a major factor in successful sales.

PROPER ATTIRE

Six percent of the artists surveyed claimed to dress the part of the artist as a sales gimmick, and 20 percent of the average artists tried to dress well to exude an air of success. Interestingly, only 27 percent of those in the top sales group gave a high priority to dressing well; I would have thought the percentage would be much higher. Seventy percent of the artists in this category stated they dress normally and give it no particular thought, while the remaining 3 percent dress the part of the artist.

Clothes may not make the man or woman, but they are of greater importance than most artists seem to realize. In a democratic society, supposedly we're all equal and have the right to dress as we wish as long as we don't offend propriety. This may be the law, but in reality we are a class-conscious nation. The artist hoping to sell must be willing to present an appearance his or her audience finds appealing. You, the artist, are as big a factor in the sale of your work as the work itself; you can't afford to turn people off by your appearance. The artist and his or her work are a single package being marketed. The public may feel sympathy for the starving artist, but will be uneasy in dealing with someone who looks like a rebel against convention. People who buy art have to have surplus money in order to spend hard-earned dollars on what many consider a luxury. Most people in this category have had to find their niche in conventional society to accumulate a surplus. They may envy the artist his or her freedom and resent the fact that they, stuck in nine-to-five jobs, are denied this same freedom. By dressing decently and neatly, you do not call attention to the differences in your life styles. Furthermore, if you look destitute, the customer may assume that you are down on your luck and ready to sell at bargain prices. But if you dress successfully, it will be assumed you are successful.

Granted that after arising at 4:00 A.M., driving 250 miles to a show, and then doing the hot, sweaty job of setting up your display, comfort becomes paramount. However, as long as you're hauling a ton of work to the show, a shirt and slacks or a dress can't increase the load much; and changing to clean clothing in the back of your van prior to the show's opening isn't that difficult.

What about the type of person my mother used to assay with a glance

and term "a character"—the extrovert who, by eccentric dress and actions, calls attention to himself? Most people are probably amused by such characters, and I don't think odd behavior is necessarily a turn-off as long as it's honest. But I have seen eccentricity forced, and it was more embarrassing than amusing. You must not lose sight of the fact that you're selling art as well as yourself; if you oversell eccentricity, people will only laugh and move on—without your product under their arms. What you are selling might also have some bearing on the image you're projecting. I don't think my friend who asks $3,000 for his paintings would get many inquiries if he were dressed like a clown or a tramp. I am not suggesting that everyone rush out and invest in a $200 suit. What I am suggesting is that you present a respectable appearance because customers are turned off by dirty hair and clothing.

PROFILE OF THE ART-FAIR ARTIST

Art-fair artists range in age from the late teens to the late seventies. To calculate the average age, I would have had to ask for exact figures in the survey, but how can a gentleman of my vintage ask a lady her age? In regard to sex, participants are about equal in number, with six men to every five women. Surprisingly, the average artist has been attending art shows for only four and one-half years. Those who are in the upper 3 percent of sales have been at it only slightly longer, averaging five and one-half years. In this latter category, however, 22 percent have attended for ten years or longer. This would suggest that the more successful artists stay with it, while the less successful ones drop out and are replaced by newcomers. As art shows increase in number, they draw in new artists constantly.

Another reason behind the rather short tenure indicated by the survey is due to a pattern I have witnessed among some of my artist friends. Initially tied to a not-too-exciting, nine-to-five job, they take art courses as an escape or to pursue a hobby. This leads them to attend art fairs, and after some consistently high sales scores over a period of a few years, they feel secure enough to give up their regular jobs and commit themselves entirely to making and selling art. For the next few years they are feverishly active, draining themselves by entering every weekend show in sight and spending the weekdays in production. Eventually the physical stress takes its toll and they start to pick up on other outlets such as wholesaling, gallery representation, or selling entire editions through dealers brought their way by street exposure. They then drop the marginal shows, but still try to make the five to ten shows a year that have been good to them. The average artist attends eight shows per year, while the more successful one averages slightly over twelve.

According to the survey, artists are lured to try their luck in street selling by a number of factors in addition to the financial returns. The largest percentage claimed customer contact as a prime motivation. Gallery problems—lack of gallery contacts, the high percentage demanded by galleries, and difficulty in artist-gallery relationships—came second. The success of other artists was the third most cited motivation.

Should you decide on street selling, you will be joining what I feel is a rather select fraternity. I find that artists, no matter where they come from, are open and friendly, and accept you at face value with no artificial barriers separating you. Let a rainstorm come up, and five sets of hands will appear from nowhere to help you with your plastic covers; if you need a hammer and nail, you needn't walk more than a few spaces to find them cheerfully offered to you; if your display goes down in the wind, you'll get help and sympathy; should a real calamity befall you, someone will pass the hat. I don't know what accounts for this openness unless it is that artists are at peace with themselves. An occasional grouch may creep in, but he or she will be left alone. Taken as a whole, you won't find a nicer group of people anywhere.

GIVING STREET SELLING A TRY

Although continuing to enter shows does not guarantee eventual success, there is much to be said for perseverance, for if you are observant and willing to adjust and improve, the possibility of financial success is greatly enhanced.

I don't think I've ever gone to a show where I didn't learn something that was beneficial to me as a street artist. I may have learned only that I didn't want to repeat that particular show because of low sales, but even this was useful knowledge.

George C. Scott, the Academy Award–winning actor, when asked to account for his success, said that when he first started out in show business there were thousands of actors better than he; most, however, became tired of the struggle and entered other lines of work, so that his success was merely a matter of survival.

I've seen starry-eyed young artists, fresh out of graduate school, pack it up and leave after the first day of their first art fair, vowing they'd die rather than be caught on the street again. I feel sorry for them, because with such an attitude they stand small chance of success in any endeavor. I'm not saying that selling art on the street or in a mall is for everyone. You must process or develop the temperament for street selling if you are to succeed. There are some people whose egos override social concerns so completely that they can't be civil to a public that has not had the benefit of their training. There are also those who are so fearful of rejection that

they prefer to stay in their little dream worlds, isolated from judgments that could be ego-destroying. These artists would be better off making the gallery scene, and more power to them if they can swing it. Life is too short to torture yourself by being trapped in unbearable situations; but most mature artists recognize the potential in street selling and are willing to put up with some discomfort to achieve a goal. Many of us, for various reasons, have found street selling "the only game in town."

If you are the sort of person who genuinely likes people and can enter into conversation with ease, and if you have faith in your product and are willing to analyze your acceptances and rejections and benefit from this evaluation, then you owe it to yourself to try for a career in art-fair exhibiting.

3

HOW ART FAIRS WORK

If you have been involved in competitive salon shows, you will find many differences between this type of show and the artist-participant show. Paramount among these differences is the fact that in a street show you are present with your work, and your goal is to sell rather than solely compete for the prize monies offered. Prizes, however, can be the frosting on the cake, and you will find that few artists disregard the possibility of winning an award.

No two shows are exactly alike, but they can be broken down into two broad general types: the mall or indoor show, and the street or outdoor show. As they are distinguished by more than differences in location, an explanation of their characteristics will give you an insight into the show scene.

THE MALL SHOW

The mall show is a development of the past decade or so, when shopping malls started springing up around the country. Many malls were built in locations of anticipated growth, which means that they were constructed on the edges of large metropolitan areas and were often surrounded by cornfields staked out for suburban real-estate developments. As Americans are convenience shoppers and would prefer to shop close to home, efforts were made to draw shoppers to the newer malls. The promotional attractions included antique car shows, new car shows, antique shows, coin shows, mineral shows, and of course, art shows. The arrangement was mutually beneficial: the shows drew customers to the malls; also, they allowed the participants to show off their wares and, in the case of art shows, to sell their artistic efforts.

Running mall shows is time-consuming, as anyone involved in mounting an art show can testify. Mall operators are only too happy to turn this responsibility over to anyone capable of putting together a well-run show, preferably with no cost to the mall. The mall-art-show promoter, an individual rather than an organization as with outdoor shows, assumes this responsibility and is involved in running shows for personal profit as well as for the benefit of the artists. Since the mall doesn't pay the promoter, he realizes his money from renting space to the artists, and in some instances,

from a percentage of the sales. As promoters increased in number, they began competing for the available malls. To secure shows, promoters started paying the malls a fee. Some mall fees run to over $4,000 for one show; the artists pay for this fee through their entry fees of $30 to $110 and in some shows, turn over from 10 to 20 percent of their sales to the promoter. Some promoters run open shows where any artist may apply, and entrance is gained by submission of slides showing the type of artwork the artist is engaged in. Other shows are closed, in the sense that the promoters will book a selected group of artists into five to thirty malls for as many weekends. There are many artists who lead this gypsylike existence, traveling from show to show in their recreation vehicles or vans.

Besides having controlled climatic conditions, the mall offers the added benefit of being a promoter-run show. Once you are accepted by a promoter, you may attend any other shows being run by that person, space being available, without having to submit slides of your work for each new show. If the promoter does his job well, you have the assurance of his professionalism, knowing that every show run by the promoter will be of the same quality.

The disadvantages are that promoters are sometimes forced to run shows in a series of malls owned by one company, but the shows may not be equally profitable to the artist. Also, unfortunately, there have been instances of promoters who book shows in mythical malls and abscond with the entry fees. You are advised, therefore, to look before you leap. As many promoters advertise in *Sunshine Artists U.S.A.*, a check of back issues to test the longevity of the promoter would be a good idea. My own experience with mall shows has been limited, for in the moderate climate of southern Florida, where I live, the outdoor show has proven more successful. I know of artists who attend some of the northern and western mall shows and do very well. Of the artists surveyed, 28 percent have experienced their greatest success at mall shows, while the remainder have been more successful at outdoor shows.

OUTDOOR SHOWS AND ADMISSION SHOWS

The outdoor fair goes back considerably longer than the mall show, which is a fairly recent phenomenon. Albrecht Dürer, the fifteenth-century printmaker, wrote of having marketed his prints at outdoor fairs in Germany. How long the fairs have existed in this country I do not know, but I have been aware of them for over twenty-five years, and they have come into their own as a marketing force within the past fifteen years.

The outdoor show is usually held on a blocked-off street or in a parklike setting. Unlike the promoter-run show, the backing for the outdoor show

usually comes from organizations such as the local chamber of commerce, merchants' associations, charities, museums, and art organizations. Some make a profit, others try to break even, and some are operated at an intentional loss, with support money coming from the show's sponsors.

A few shows across the country have begun to charge attendance admissions. It's an opportunity for the promoters to gain some additional funding and, they hope, to cut down on the entry fees the artists must pay. As it is difficult to police an out-of-doors admission show, this kind of show is usually held in an enclosed area. Despite the facts that this type of show is not widespread and few artists have been confronted with the necessity of deciding whether or not to attend such a show, most artists have an opinion on admission shows. Only about one-fifth of the artists queried favor an admission show; the remainder feel it would cut the overall attendance and eliminate some of the impulse buying that occurs at free shows.

LOCAL, STATE, AND NATIONAL SHOWS

Shows vary in size, fees, prize money, and methods of selecting artists. Although there are some variations, the three major levels of participation are the local, state, and national.

Local shows are small and, as the name suggests, are put on chiefly for hometown artists. Participation is usually under 150 artists, with entry fees of around $20 to $30, and total prize money not exceeding $2,000—often much less. Entrance may be either by slide screening or on a first-come, first-served basis. Promotion is not extensive, and sales are also somewhat modest. Because these smaller shows are local in nature, their draw is also local, and they are run without concern for competition from other shows on the same weekend. The smaller shows are the easiest to get into, and are a good place to start if you lack experience. Judging, for the most part, is competent; if you have a quality product you could be a big frog in a small pond when it comes to prize money. These smaller shows are occasionally used by traveling artists as fillers between weekends of major shows. As some artists travel thousands of miles to attend shows, they try to occupy every weekend while on the road.

Statewide or medium-sized shows can have as many as 300 participants. Entrance requires a preview of your work through slides. If you have attended the same show for three or four years, the slide requirement may be waived because your work is known to the selection committee. The entry fee is usually around $30 to $45, and prize money runs between $3,000 and $6,000. Guaranteed purchase money, contributed voluntarily by organizations or individuals, of a few thousand dollars is often used as an inducement to bring in the artists. These medium-sized shows draw

reasonably well. Attendance is mainly local but can be large if the show is held in a fair-sized city. Sales are average; the only big killings to be made are in prize money. Because artists are drawn from the whole state and beyond it, some effort is made to schedule such shows so that they don't conflict with other major shows in the same general area. Scheduling is usually decided by tradition. If a particular show is traditionally held the third weekend in March, most other shows try not to schedule on that weekend. Acceptance into a show of this size is somewhat more difficult than the smaller shows. The quality of the artist's work, his medium, and the availability of show space can all be factors in an artist's acceptance or rejection.

The larger or national shows, the ones where there is severe competition for acceptances, all require slide screening. They rarely waive this requirement, and past acceptances mean little. Exceptions are made only for artists who won cash prizes the previous year, in which cases acceptance is automatic. Merit prize money is in the $10,000 range, although some major shows offer no prize money at all. Crowds run to thousands per day, and sales range from great to paying-off-the-mortgage. Entry fees are from $40 to $125, plus the $5 slide-screening fee. Artists are drawn from the entire nation and in some cases from other countries; acceptance is granted to a minimum of 200 and maximum of 400 artists, although few shows hit that number. Because of the proviso that the previous year's prize-winners are automatically accepted, and the literally thousands of applicants, these shows are the most difficult to enter. At this level, neither space availability nor medium plays much of a role. Only quality counts. Because of their caliber and reputation, major shows draw an audience from great distances. As they are top draws, they needn't worry about competition from other shows and can schedule as they wish. Most, however, have a long-established date that they repeat from year to year.

LENGTH OF SHOWS

Shows can run from one day to over a week in length, but 99 percent run for the weekend or an extended weekend—Saturday and Sunday, or Friday, Saturday, and Sunday.

A one-day show can be fatiguing because you must both put up your display and strike it the same day. Also, the emotional pressure is great, and you count hours rather than days. The one advantage is that if customers are going to buy, they are apt to do it immediately instead of going home to think the purchase over and talk themselves out of it. Week-long shows can also get to you, however, because for stretches of time the traffic is minimal, and, as you are chained to your display, boredom sets in. The

two- or three-day show seems ideal, as in most cases you are allowed to leave your display racks up overnight, and in some instances, even your work. Saleswise, no particular day of the week is any better than any other, although all artists have their own theories as to which is their best day at any particular show. Most artists are blessed with the optimistic attitude that if today was slow, tomorrow will be brisker. A disadvantage of the three-day show is the difficulty of stampeding someone into buying, if they know the artist will still be around two days later.

What is the artist's preference as to a show's length? A whopping 62 percent of those surveyed prefer the two-day show; 22 percent opted for three days, 11 percent for one day, and only 5 percent for four or more days.

Marketing your art is an important ingredient in your success as an artist, but the fact is that most artists would rather spend their time making art than selling it. Let's look at the artist's week. If you are a full-time street artist, and you travel for one day to attend a three-day show, you have spent four days out of productivity. You can write off another day for normal home chores, such as painting the porch and fixing the screen door. Strike off another day for rest and relaxation (I'm never worth much on a Monday following a three-day show), and you are left with only one day of the week for productive artistic effort. Consequently, most artists try to set aside blocks of time during their slow periods and concentrate solely on production.

Your acceptance is a commitment to stay for the length of the show. There are no kind words for artists who withdraw from a show after the first day, either because they felt slighted in the judging, they didn't like their location, or for some other reason of this kind. If you must withdraw from a show for a legitimate reason such as illness, be sure you talk to a committee member before you leave, lest your application the following year be rejected.

JUDGES AND JUDGING

Just as entry fees increase from year to year, the prize money offered at shows has also increased. As quality of product plays such an important role in gaining acceptance into shows, more and more entrants are becoming plausibly eligible for the prize money. Judges, judging, and the prize money should be seriously studied by any artist who hopes to make it on the street.

You probably consider yourself to be a fair and honest person with concern for other people. Judges are human beings, as honest and fair as you assume yourself to be. There is no evidence that donning a judge's badge and picking up a clipboard automatically turns one into a combination of

Machiavelli, Jack the Ripper, and Adolf Hitler. Having worked both sides of the street, as a competitor and as a judge, I would hestitate to accuse any judge of dishonesty or failure to do his or her very best. The judge is picked by the show committee, which assumes that because the person selected holds positions of prestige and responsibility—as a museum director, art professor, artist, craftsman or whatever—he or she has sufficient knowledge to pass informed judgment on artistic efforts.

Judges are products of their backgrounds, training, and current involvements. They have their own interests and prejudices as we all have, but it is hoped they will not let these interfere with fair judgments. It has been said that upon being elected to the Presidency of the United States, a person, regardless of background, rises to the position. The same should be true of an art-show judge. Judges, I've found, will select work above their own level of achievement, and they can admire styles different from their own. A judge who may be expressionistic in his own work will recognize and reward someone whose work is basically classical, if that work is the best in the show. Judging is a difficult assignment. The judge is faced with the arduous tasks of reviewing hundreds of works under less-than-perfect conditions and reaching decisions within a limited period of time, all the while knowing that the efforts will be applauded only by the few who meet his or her criteria for excellence.

No single aspect of sidewalk shows comes under as much criticism as the judging. The most frequently heard lament is: "He walked right by my display and didn't even look." In answer to this, I must say: don't kid yourself; he looked, but he didn't see anything of sufficient interest or drama to hold his attention. Any judge worthy of the title is able to walk through a show and immediately spot the artists whose display and work gives evidence of professionalism; these are the artists worthy of consideration.

Judges haven't always met my expectations. I recall a judge who stated to the press after judging a major show, "I didn't expect to see any great art out here, and I wasn't disappointed." I recall the judge who awarded a printmaking prize to a sculptor and a painting prize to a photographer, although prizes were to be given within categories. In still another show, the judge failed to pick sufficient prize-winners for the lesser awards, so he distributed that prize money among the top five prize-winners in each category. In all these instances, I hold the show committee guilty as well as the judge. It was the committee's responsibility to pick a judge sympathetic to sidewalk shows, and then inform the judge of his or her responsibility to meet the rules published in the show's brochure. The printed brochure is a contract with the artist and must be honored. If it isn't, you

have every right to make your displeasure known to the committee.

Mistrust of judges was reflected in the survey, with almost 20 percent of the artists preferring a vote by the public. An out-of-state artist or craftsperson was preferred as a judge by the largest number of artists. The local artist or craftsman ranked second, art critics and museum personnel came next, and the art professor or art historian was at the bottom. The artists seemed of the opinion that academic types were too avant-garde and not attuned to the reality of street shows. Most artists, as indicated, would prefer to be judged by their peers; the artists in the upper 3 percent in sales preferred the out-of-state artist or craftsman by 44 percent.

The preceding analysis would indicate that the street artist has not become reconciled to the realities of judging. Work is judged and prizes are awarded to bring the better artists to the shows, thus upgrading the show's quality, and also to raise the tastes of the buying public. These better artists must be rewarded or they won't attend, and the show will diminish in stature. To ensure that quality is recognized, judges are selected on the basis of their knowledge of contemporary trends. Great art is not necessarily the most popular with the general public.

All artists would like to have a judge knowledgeable in their specialized category, but as that would mean 40 or so judges, it is an impractical suggestion. Most committees try to pick judges with as broad a background as possible, and if more than one judge is hired they try to select those whose major interests don't coincide. They will select one judge in the fine-arts area and another whose specialty is crafts, or they may go for a judge specializing in two-dimensional art and another specializing in three-dimensional art.

I've often heard the somewhat serious charge that the judging for a show was "fixed." In all my years of show attendance, I know of only one show where the charge had some credibility, and even in this instance I'd hesitate to use as strong a word as *fixed*, although it may be true that the judges selected were known to have a preference for the type of art being practiced by the local artists. When I have judged, no one has ever approached me with a dishonest proposition. I've heard the charge at art shows where I've won top awards although I knew neither the judge nor any members of the show committee; I am inclined, therefore, to discount the accusation as sour grapes.

HOW JUDGING IS DONE

There are various methods used to judge an art show. I'd like to discuss the three I've encountered.

The first is the shotgun method, which is the most difficult and least ef-

ficient because it lacks a plan. The judge or judges meet with the committee the first day of the show at the appointed time. They are given clipboards, informed of the prizes being offered, and turned loose to do their job. Most judges like to cruise the show at leisure before getting down to business; this allows them to assess the overall quality of the show and make some general notes of work they want to look at a second time. This is an important part of the judging procedure, and as the judge is incognito, many artists don't realize that their work has been looked at with some thoroughness at this point. After this initial look, the judges go through the show a second time, either singly or as a team. Working as a team allows immediate decisions to be made, because if one judge is keen on someone's work and the other judges don't concur, that person's work is eliminated. If two or three judges concur at this point, the artist's name is recorded for further consideration. After this second walk-through, the judges usually meet and compare notes, and in all probability will return to certain displays to weigh again the merits of certain artists before making final decisions. If judges make the second walk-through individually, the note-comparing session can drag on as each judge tries to defend his selections. After comparing notes, they may have to return to the street for still another look.

A much easier and more efficient method is to set aside a room where the judges can gather the work selected for consideration and then make their final decisions away from the bustle of the street. This method permits thorough scrutiny. In all shows I've judged in conjunction with other judges, there have never been major disagreements in selecting work for final consideration. It is when the judges get down to the awarding of prize money that gentlemanly arguments occur, and some trading of selections usually precedes the final awards.

A third method of judging is to have each artist in the show hand-carry what he considers his best work to a room where the judge or judges will deliberate in private. This method circumvents the accusation that "the judge didn't look at my work," but it does pose the problem of the possible lack of consistent quality in an artist's product, as the judge must make a decision on the basis of just one piece.

One method in current usage assures that each artist's work is looked at by the judge. After viewing your work, the judge or an assistant affixes a colored sticker to your display indicating that the judge has passed your way.

Some shows prefer you not to consult with the judges while they are doing their job, so as not to influence them or take up their valuable time. In fact, they want the judges to maintain as low a profile as possible. Another reason for keeping artists away from the judges is that some artists,

convinced of their superiority, do not hesitate to make their displeasure known if the judges do not agree with them. This can be a bad scene. Other shows are less strict in this regard, and some even identify the judge with a badge. As I said earlier, judges are human beings. I like to see evidence of this. When I act as a judge, I enjoy exchanging a few brief, friendly words with the artists; they may not all be great, but they are all human. As for the artist being judged, a word or two from the judge indicates he has recognized the artist as a person, whether or not their tastes are the same. A judge with a friendly manner helps soften the blow of a rejection.

PRIZES AND HOW TO WIN THEM

There are three types of awards given at shows: merit awards, top purchase prizes, and so-called purchase awards.

Merit awards may be given in or out of category. "In category" means that there are first, second, and perhaps third awards given in each specific category—usually painting, watercolor, sculpture, printmaking and drawing (usually lumped together as graphics), photography, and crafts, although categories may change from year to year. There also may be ten or twenty out-of-category awards at the same show, worth from $50 to $150 apiece. Out-of-category awards are prizes given irrespective of medium. Five $500 top awards may be given, and it is possible that they may all go to one medium rather than being distributed by category. Usually a few thousand dollars is also distributed in minor awards, which are also out of category.

The top purchase prize, if offered, is the grand prize in the show and is purchased by the show sponsor. It usually runs to $1,000 or more, and is given for the work the judge feels is the best of show without respect to medium. It may be tacked on to the top in-category award, although this isn't always true. The artist has the right to accept or reject the purchase prize depending on whether or not the amount offered equals the asking price of the work. I've rarely seen it refused, because the prestige of receiving the award offsets any financial loss that may be incurred.

Purchase *awards*, also confusingly called purchase *prizes* at some shows, have nothing to do with the judging. Organizations or individuals will pledge X number of dollars to make a purchase at the show. These awards may run to thousands of dollars in total, but as they are selected by the patrons, they will reflect their tastes and do not necessarily mean that quality is recognized. Years ago these purchase awards were selected by the judges, but the patrons who were going to have to live with works selected by judges raised loud protests. The purpose of the purchase award originally was to bring better artists to the shows, but with the change in

the selectors of these prizes, their intent seems to be to lure any artist to the shows.

PRIZES OR SALES?

The dilemma of whether to go after prize money or sales was stated by one of the artists, whose comment was to the effect that "if I don't make sales, I can't travel or eat—and if I don't win prizes, I lack prestige, which the promoters want." This raises the question: How essential for sales is the winning of prize money? Although opinions may vary, it has been my experience that winning a prize doesn't hurt sales; however, only on rare occasions have I sold work because it has won a prize. The reason is obvious. Judging is generally done by professionals with knowledge and tastes that differ from those of the buying public. People who purchase work on the street aren't going to buy what doesn't appeal to them, no matter how impressive the work may be. The dilemma of which way to go, prizes or sales, is further complicated by the procedure for entering the more prestigious shows. Screening committees will select avant-garde work to raise the level of shows, although the possibility of selling work of this type is miniscule compared to the more conventional work. Serious artists interested in personal artistic development find the problem frustrating because work that will get them into shows sells poorly; and the artist with a marketable product is often denied entrance by the very fact that his or her work is marketable.

Many artists of my acquaintance try for both sales and prize money by bringing two types of work to a show. As the first day is usually given over to judging, these artists will display only four or five of their best works, hoping to catch the judge's eye. If successful, they are under obligation to keep the prize-winner on view throughout the show, but they will fill the rest of their display with the more saleable items on the second day. If the judge walks by and no recognition is forthcoming the first day, they immediately switch to the more marketable work. I'm not necessarily advocating this method of operation, only reporting it. In the better shows this switch may not be possible, as committees will check out the artists' displays periodically to see if the work they have on display is of the same quality as the slides that were sent in to gain entrance into the show.

Despite the hue and cry over judging, none of the artists in the survey admitted to entering shows only for the prize money, and only 3 percent stated that they concentrate on prize money but also consider sales. Over 50 percent of the artists claim to care not a whit about winning prizes, but concentrate instead on sales; and over 40 percent give both sales and prize money equal consideration.

This question of prizes or sales will arise after an artist's first show appearance. It will also surface after every show attended where expectations weren't met; then previous decisions are questioned. This is not bad, as a constant reevaluation of the direction the artist is taking is almost a must if he or she wants to hit the top and stay there.

Another participant in the survey described the direction most artists seem to take, stating that he tries for "good quality work that may win prizes, but that will also sell audiences." Saleable art does not *have* to be bad art, but finding an area where you can be honest with yourself and still present appealing work is paramount if you are going to delight in your success. Every artist out on the street, although not concentrating on a prize, and no matter how unpretentious his offering may be, still hopes that the judge will favor him with an award. However, most will take $500 in sales in preference to a $100 prize if they have a choice.

HOW TO WIN PRIZES

Going after the prize in a street show is as difficult as winning in a competitive salon show. Although the street show has the advantage that fewer artists go after a single prize in a single category, the artists, to make their presence felt, are faced with the necessity of displaying a body of quality work in a consistent style. In a salon-type show, one work is all that is necessary to display, and the artist is judged solely on that effort. No artist is going to end up in the winner's circle unless he or she makes a commitment to that goal. There are no surprises. Artists who win prizes with consistency are those whose product is so superior to the other work in the show that there can be no question or doubt as to their winning. The winners are usually the better-educated artists who continually sit in judgment on their own work and are willing to make the changes necessary to put and keep themselves on top. If an artist failed to win last year, there is more than probable reason to believe he or she won't win this year unless the quality of his or her work has been significantly upgraded. Judges are knowledgeable about contemporary trends and what is avant-garde; they will tend to select work of this type, which exhibits more originality than any other. Skill in manipulating some long-dead movement or trend is not going to make it.

TRADING

Bartering or trading of work is of two types: first and most prevalent, trading with fellow artists; second, trading with customers for services or merchandise.

Although one-fifth of the artists in the survey refuse to trade their work,

80 percent are not averse to it. If an artist admires the work of a fellow artist, and feels his or her work is of a similar quality and in the same general price range, he or she may suggest a trade. The worse that can happen is to receive a "no" answer. In all likelihood, the artist approached will volunteer to stop by the first artist's stand to see if there is anything of interest. If he finds the work appealing, he will probably make the next overture. If he is not interested, the issue will be dropped. Although 37 percent of the artists claim to welcome bargaining, most are reluctant to make the initial contact for fear of being rebuffed. One should never hesitate to ask, as the booty from trades is a fringe benefit of show attendances. I have hesitantly approached artists and suggested trades, to find that they had considered asking me but were fearful of a rejection. If it's early in the show, the artist approached may want to hold off until the last hour, in hopes of a cash sale before that time. Possibly both artists may prefer to wait for the same reason. You must be careful that trading doesn't get out of hand. I recall one show where I traded a small painting for a fine piece of pottery. Word of the trade got around and I was deluged with requests for swaps. As it was early in my show career, I hadn't developed a way to say no politely, and I ended up with items I didn't really want.

Besides acquiring art which one admires, there are other benefits that may sway an artist to consider trading his or her work for that of other artists.

One artist I've heard of turns trades to profits. He will trade for work that has a public appeal, although he may not covet it for himself. He hangs the traded work in his studio, and if customers who stop by find nothing of his that they wish to purchase, he is not averse to selling the work he has received in trade.

There is still another way to capitalize on traded items. Most artists receive requests from fund-raising organizations to donate work to be auctioned off. I received four such requests during one recent year. Government regulations will allow the artist to deduct for tax purposes only the material costs of the work he donates. If, however, the donated item is the work of someone else, and the giver has a bill of sale to prove its value in a legitimate transaction, the entire amount then becomes deductible. Be prepared to prove the value of the work donated.

If art is given as gifts, your friends and relatives may already possess too many of your works, and traded artwork by other artists will add variety to your gift-giving.

Swapping with customers for services or merchandise is usually done on the local level; obviously, it's unprofitable to travel 250 miles to have your teeth cleaned by a dentist who traded his services for your work. If,

however, a major dental repair is needed, a swap of this kind can be profitable. If a customer's profession is known and you feel you can use his services or product, you may suggest a swap should you be forced into a bargaining position. Where a sale might not even be considered, it may be possible to make a trade if the customer is aware of your willingness to swap. I don't know of an easy way to make this willingness known, short of hanging a sign on your stand stating that you'd consider a freezer, a ten-speed bike, or a set of dishes as part or full payment for your work. You could try the trade section that many newspapers carry in their classified ads; also, many condominiums, laundromats, and supermarkets offer free bulletin-board space, where needs can be posted along with pictures of what you are willing to trade. One of my students happened to stop for gas on her way to school, and the service-station manager admired the painting she had in the back of her station wagon; she offered to trade it for two new tires, which she badly needed, and he accepted. One never knows when the opportunity will present itself for you to make a profitable trade. All trades are considered sales and must be reported as income and sales tax paid on the transaction.

WHOLESALING

Wholesaling of work, or selling to a dealer who will resell it at a profit, is an opportunity often presented to an artist who has an item that can be mass-produced at a fairly low cost. Artists who make expensive one-of-a-kind art objects, such as painters, sculptors, and weavers, are seldom approached by dealers. Potters and an occasional jeweler may be able to sell off everything that remains after a show to a single dealer or outlet.

In anticipation of such an opportunity, it is best to have a figure in mind that will allow you a fair profit. I've seen artists, caught unprepared by the heady opportunity to move a large amount of work, give a wholesale purchaser 50 percent off their street price and, consequently, realize very little money on the sale.

As a purchase of this type usually involves considerable money, it is wise to make doubly sure the buyer's check isn't rubber or the credit card stolen. Discounts are negotiable, so one shouldn't be timid about mentioning a smaller percentage than the one offered. Some have given one-third off to a dealer and then found that the same dealer bought from another artist for only 20 percent off his street price.

Being "in the trade," or claiming to be a dealer, is a ploy often used by anyone who wants a reduced price on the purchase of only one or two items. If the item is expensive enough, check the purchaser's business card

and then go along with the sale. If it is one or two small items, refuse to sell unless the dealer agrees to meet a $100 minimum.

COMMISSIONS

Any artist, regardless of his product or price, may be approached by someone with the request to execute a work of art to specifications dictated by the purchaser. Portrait artists are most frequently the recipients of such requests, although it can happen to any artist or craftsman whose style the patron may admire but not necessarily the particular work being displayed. A quarter of the artists questioned have been offered and accepted commissions. Some deals have come off very well; others can present problems. As the instructions for commissions are often verbal, the patron may have imagined a different end product than what the artist envisioned, and consequently the object produced may be unsatisfactory. I have shipped commissioned works across the country only to have them rejected, despite the fact that I felt I was following specifications perfectly. Occasionally the patron will express dissatisfaction with the end product in order to talk the price down from what was originally agreed upon. Commissions, although flattering to receive, may prove more of a pain than they are worth. There is no way artists can really safeguard themselves. Requiring half of the total sales price at the time of the commission is not going to guarantee eventual purchase, but it might take some of the sting out of the rejection. However, it will still leave you with a dissatisfied customer and a work that will be difficult to market. A sculptor in the survey also mentioned that his commissions are never for major works, but only for his more commercial, mass-produced items, and he finds himself spending too much time cranking them out instead of doing serious work. In doing commissioned work, too much time can be spent in dialogue and in getting approval of the work in various stages of completion, with the possibility that the end product won't be acceptable. These experiences should not prove a deterrent to any one wishing to accept commissions, but should serve as a warning that the road isn't always smooth.

GALLERY INVITATIONS AND OTHER FRINGE BENEFITS

I've heard artists who should know better express the concern that "if I sell on the street, no legitimate gallery is going to be interested in handling my work because I'll be considered a less-than-serious artist." Nonsense. The sidewalk show is a great opportunity for gallery owners as well as others who deal in art to look for new talent. Of the three to four hundred artists at any major street show, there are bound to be some worthy of representation in just about any gallery in the country. When a gallery director walks by a booth and sees "sold" stickers on everything displayed, he

knows that the artwork is a proven seller. That fact alone could save him thousands of dollars he might lose by promoting someone without proven sales potential. No dealer is going to be turned off if the artist seeking gallery representation opens his books and shows an outstanding sales record. This may seem contradictory to my earlier statement that New York galleries rarely seek talent in the hinterland, but it's not. Taste-making major galleries won't be found surveying art fairs any more than they will be found at major competitive shows outside New York City. Many local or statewide galleries do attend, however, and artists have been contacted by gallery people who have traveled as far as fifteen hundred miles for the purpose of finding proven saleable artists to represent. One-fifth of the artists surveyed have made gallery contacts through their street participation.

One artist whose work is priced in the $3,000 range goes to one or two prestigious street shows a year, not really expecting to sell but hoping for prize money and gallery contacts. Last year a gallery did find him and presented him in a one-man show where he sold one painting, his percentage amounting to $1,500. Another gallery owner saw his work at the gallery exhibit and after the show, purchased twelve paintings for $1,500 apiece. By agreement with the first gallery, the artist returned to it $500 from the proceeds of each painting sold, and ended up with $13,500 as a direct result of his participation in a two-day sidewalk show. Lest it be felt that I overstate the facts, I suggest that you talk with any street artist who has been selling for a number of years. All will have stories to relate of artists who picked up gallery representation, were purchased by a museum, were asked to a major invitational, sold a small drawing for $1,000, or in other ways too numerous to recount reaped a huge benefit as a result of being in a sidewalk or mall show.

Some galleries, if they are located near the show in which the artist is participating, may insist on exclusive representation in that area, and may require that he or she no longer sell on the street in their locality. Unless they prove over a year's time that they can do better than street-fair sales, the artist might profit more by not dealing with them but remaining his or her own agent.

The survey results strongly indicated that anyone who has been involved in street-show selling for more than one year has realized benefits above the immediate sales. Exposure is the name of the game. Contacts can't be made if work is kept in the closet; it's much easier to have potential customers come to you than to wear out the U.S. mails and your shoe leather attempting to track down the dealers or galleries that could be of help.

As a result of the street shows I attended in one recent year, I was in-

vited to send some prints on consignment to a New Jersey gallery as they were preparing for their summer season; another gallery, about to open, asked for some of my paintings on consignment, with the offer of a future one-man show should my work prove marketable; a charitable organization assembling a benefit show asked that I donate one print and hang another ten, with 60 percent of any sale to be returned to me; and a dealer made an outright purchase of one of my plates, which will be printed and marketed. These are the fringe benefits I enjoyed in just a single season. In addition, the best gallery I was ever affiliated with asked for my work after the owner saw some of it at an art fair. Such benefits resulting from exhibiting your work on the street suggest that you cannot afford to pass up the opportunity to attract the attention of gallery owners, wholesale buyers, and others who are in a position to help you market your art.

4

ENTERING SHOWS

When you decide to try your luck at the artist-participation shows, you will have to decide which shows to enter out of the hundreds available to you, and learn how to gain acceptance into the shows of your choice. This selection process is more than guesswork, and correct selections can mean the difference between average and high sales.

The survey indicates that past experience with a show was the most significant factor taken into consideration by the veteran artist when determining which shows to enter; 36 percent gave it top priority. For those new to art fairs, 31 percent said they relied on the experience of other artists in selecting shows to attend. Proximity of the show came third as the reason for selecting a show. The publicity the show received came fourth, and only 4 percent claimed to be lured to the show by the prize money.

In analyzing the survey, we are dealing with two different types of artists, those whose means or circumstances limit them to local shows, and those who place no restrictions, in terms of time or distance, on which shows they attend. We will look at each type separately, as each uses different criteria upon which to base a decision.

SELECTING SHOWS FOR THE
DISTANCE-RESTRICTED ARTIST

Two-thirds of the artists attending shows are unable to travel great distances to shows because of their employment or other considerations, and most must choose their outings from shows within a 300-mile radius of their place of residence. The artist forced to operate within easy driving distance from home will still be forced, after making a first choice, to weigh the merits of additional shows he decides to enter, in order to make the best use of his time.

If you have confidence in your product, your best bet is always to shoot for the top. The bigger shows bring out buyers by the thousands, and one weekend at a major show can equal the returns of four or five minor art fairs. It costs only a $5 slide-viewing fee to see if you can play with the big boys, and the opportunities are so superior that you can't afford to deny yourself this chance. As there are not enough big shows locally to add up to the eight shows the average artist enters annually, you will have to re-

view your options to decide how you are going to fill your leftover dates.

Don't place too much faith in the promoter's literature. I recently attended a week-long show that boasted over 168,000 in attendance the previous year. It sounded great. What I discovered was that the show setting was surrounded by slums, and that half of the so-called patrons materialized from the area adjacent to the show. They were viewers, not patrons, as were the 42,000 children who were bused in daily to fill the morning hours of the show. Of the remaining 42,000, many were driven off by inclement weather or else found other activities to engage in on the few days the sun honored us. The net result was that although returns were no greater than those realized at an average weekend show closer to home, expenses were three times average. We were fortunate to have broken even.

Some events billed as art shows will prove to be only part of a festival, and the public's day will be filled with a continual bombardment of local talent performing within the confines of the art show. A third of the artists found this activity unobjectionable, if kept within limits, and felt it actually drew some crowds. About half of the artists preferred a show devoted solely to art without these added distractions. My experience is to go along with the 50 percent. It is impossible to talk sale if you are next to the bandstand featuring a rock group with amplifiers turned up full volume. True, many people will show up, but they are there to see their little ones, in pink leotards, twirling their batons. I recall a real horror of a show a number of years ago where fortune, or a diabolical show chairman, placed me next to an alligator-wrestling booth. Parents balanced their children on my display throughout the day to improve their view of this cultural event. Fortunately for me, although unfortunately for the poor alligator, his leg was broken in the final bout of the evening, and no suitable replacement was found for the second day.

Except for the big shows, where everyone does reasonably well, entering a show can be a gamble. Many variables can affect the scene and destroy what you had hoped was going to be a big-selling show. Bad weather, other attractions in the same area on the same weekend, or a major show coming the next week in the same area can all prevent the realization of your expectations. The opposite can just as well happen. It can be the first nice weekend in a month and customers will turn out in droves, gallery and wholesale buyers will appear with their checkbooks, and the judge may turn out to be your long-lost brother whom you haven't seen since childhood. These are some of the reasons it is best to hold off making judgments and directional changes in your work until you have attended a number of shows and can get an overview of your situation.

After you have tried for the big shows, give careful consideration to the second level of shows you select. It may be advantageous to jump from your major shows down to the locals, if the profits would be greater than what you'd realize at a larger state show some distance away.

Shows within a fifty-mile radius of your home have the advantage of allowing you to sleep and eat most meals at home. Your only expenses are lunches, gas, and your entry fee. You will save the considerable amount that would be spent if you traveled a greater distance and had to spend a few nights in a motel, plus eating out. It's possible to turn a profit on these short-distance shows, even though they may be local in nature and the sales smaller, because of the savings in travel, lodgings, and meals.

Sometimes considerations other than money dictate choices. I entered two shows recently simply because of the locale. Both were in resort areas with fine restaurants available, and the shows' surroundings were most pleasant. I looked on these shows as free vacations, expecting to make just enough to pay expenses. Indeed, that was all I did at either show, but both were most enjoyable experiences.

There are some publications available which are of tremendous help to the street artist in deciding which shows to enter. There are announcements in national magazines devoted to art and the crafts, and also in some publications devoted solely to keeping artists informed of the show scene. One of the latter is a monthly publication entitled *Sunshine Artists U.S.A.* (published by Sun Country Enterprises, Inc., 501–503 North Virginia Avenue, Winter Park, FL 32789). It's a "must" publication for any street or mall artist, as it is a clearinghouse for information. Its editorials are pointed, and they keep you up on what's happening—and what shouldn't be happening—at the mall and sidewalk shows. Reporters give information pertinent to their individual states, and a few columns on specific topics are included. The magazine reviews shows that have taken place and evaluates each show reviewed. The big thrust, however, is in the listings in the back of the magazine, which announce upcoming shows by the month for the entire nation. This listing usually contains information on over 400 shows per issue. The information includes the location and dates of the show, what media are acceptable or unacceptable, the entry fee, the last date for mailing your entry forms and fees, and the person to contact for application forms. Individual promoters of mall shows as well as some street shows place ads, as do some purveyors of street-show necessities.

A second useful publication is the annual volume *Audit*, also published by Sun Country Enterprises. Priced at approximately $25, it is a bargain because the information it contains can direct you to the more successful

shows and allow you to skip those with lower ratings. *Audit* lists 2,500 shows across the United States and Canada; those in the United States are arranged by states. *Audit* reports of the past four years are noted, as well as some general information. The list is not inclusive, as only 25 percent of the 10,000 shows held annually are reported; but they are considered to be the most significant shows being held.

Picking a show at random from *Audit*, and reading the results of the past four years, I find it rated at 3, 4, 6, and then 7. This would indicate that it is a show on the rise, and not too far from breaking into the big time if it continues to improve; it is, therefore, worth traveling to attend. A show with a rating of 4, 4, 4, 4 would suggest it to be a local show that isn't aspiring to grow, and isn't likely to. A show with this rating would hardly be worth a 1,500-mile trip to attend—perhaps not even a 30-mile trip. *Sunshine Artists* has 200 unpaid, uninfluenced auditors who send in their reports on the shows they attend. Their reports are a consensus of the opinions of a number of artists at the shows, and not an individual view. As a further safeguard, at least three auditors send in reports on every show that is audited. The publishers have plans to send out updated reports twice a year so that artists can stay current. In addition, the book contains a list of preferred professional promoters, and another list of the top 24 shows in the nation.

SELECTING SHOWS FOR THE TRAVELING ARTIST

Over half of the more successful artists place no limit on the distance they will travel, which probably means that their sole income is derived from shows. About fifteen hundred miles is the farthest that most artists have found it necessary to go to fill their itinerary. For this group of artists, who are not restricted from traveling great distances to a show, the audit book should be a bible. I don't know how many artists I've encountered at small, run-of-the-mill, low-profit shows, who had traveled great distances to attend just that one show, simply on the basis of hearsay. I often thought it must be a long, lonely drive back to Michigan in their vans still full of unsold work.

The slowness of many shows in notifying artists of their acceptance or rejection poses a real problem for those who must travel great distances to attend, and it can force them into some unethical practices. For example, a northern artist who is planning on spending a winter month in Florida will pick four of the largest Florida shows listed on the four weekends he will be there. Knowing that he may not be accepted in all four, and that he will not be notified in time to make other plans, he hedges his bet and signs for four other, less competitive shows, where his chance of acceptance is all but assured. Let's say that he is accepted into two of the major

shows and all four of his second choices. He will plan on the two major shows and two of the minor ones and will airmail a letter to the two unneeded shows, hoping to get his entry fee back. As the shows closed their books when the announcements went out, the promoters are reluctant to refund the money. Even if they keep it, they are still left with vacant spots in their shows unless they have a reserve list of locals to fill these spots. As the two unused spaces cost the artist only $60, he will simply swallow his loss. I don't think this way of doing business laudatory or satisfactory, but the only proper solution would be to send out acceptances and rejections at least two months prior to a show.

There is another current practice that is less than ethical. It's generally done by traveling artists, although some locals are just as guilty. The artist will sign for two shows within reasonable driving distance from one another, on the same weekend. He will attend the most promising show the first day, and if it turns out to be less promising than anticipated, he will switch to the second show on the following day. This switching is not fair to either the promoter or the fellow artist who was cheated out of acceptance to a show as the result of someone's greed. I don't know if promoters have blacklists, but it may be time for them to start, if only to weed out some of these undesirables and keep their shows healthy.

As shows are continually changing, it is wise to keep an eye on audits and try to update yourself by talking to other artists. Show committees change, and what was a less-than-adequate show four years ago may have turned itself around and be on the rise. I know of just such a show. Fresh blood at the top, a super screening committee, and increased prizes turned this show around, though I had vowed never to attend it again, and changed it into a show with top artists and steadily growing crowds and sales. The quality of the show has enlarged its drawing area to a 100-mile radius.

YOUR SHOW OF SHOWS

A comedian has what he calls his "room." It's a particular night spot where he is always a huge success. Some of this phenomenon is unexplainable, but one factor is evident, which is that he has built a large following of admirers who will show up every time he appears.

Artists likewise will have shows where they always do well, although no one else at the show may be selling. Two-thirds of the artists have a show or two where they consistently do well. The remaining one-third find that if everyone else is selling, they sell; if sales are off for the majority, they also suffer. Of the more successful artists, over 90 percent stated that they have their "show of shows."

My "room" is a local show where, because of my art involvement, I am

best known. This past year, when others at this show were complaining about plummeting sales, my sales were as good as in the five previous years. The recognition I receive is a result of several factors: my position at the local university, frequent demonstrations and workshops, judging at local shows, and the fact that I have taught from time to time for various local art organizations. My biggest problem at this show is breaking away from friends and former students long enough to wait on customers. My repeated attendance over the past ten years has built up a following. I am on a first-name basis with many of my customers. I know their likes and dislikes, and would estimate that at least a quarter of my sales goes to these established customers.

Your challenge is to turn every show into a "show of shows" by making yourself recognizable.

MAKING YOURSELF KNOWN

There are three ways of developing a following and thereby increasing sales. Most artists use the obvious one of repeating shows, and ignore the self-promotional aspects of publishing a brochure, or of becoming their own public-relations agents. Of the artists surveyed, 77 percent felt that repeating a show is important. Among the big-selling artists, 87 percent felt it important. Almost half of the artists have experienced increases in sales as a result of repeating the same show. My own experience gives credibility to the necessity of repeating shows annually.

There is a major show that I attended regularly for seven years, and my sales were quite respectable. After dropping out of attendance for five years, I once again attended the show this past year, and my sales were only half of my previous average. It was a show where I had always had repeat customers and some referrals when attending regularly. At this last outing, only three people mentioned that they remembered me from previous years. Here's another example. Ten or so years ago I was represented by a gallery that sold unusually well for me, particularly in a suburb of the city where the gallery was located. By good fortune, I became one of the artists whose paintings it was prestigious to own. After three years of operation, the gallery folded. I didn't return to the area until eight years later, when the suburb that had done so well for me started its own sidewalk show. I attended, hoping that the fire that had burned so brightly was still smoldering, and that I'd do reasonably well because of my previous performance. Not true; I had been away too long. I was not recognized and there weren't any sales. If it hadn't been for a fortunate trade, I would have returned home empty-handed. You can't stay away from a show for several years without losing the customers and the referrals that they bring.

Street selling is cold selling. Unless you have repeat customers or a referral, you and the customer are meeting for the first time. Although the customer thinks he knows what he likes, he is not sure that he is making the proper purchase. He wants assurance that what he is spending his money on is worth the price you are asking. Giving this assurance without sounding egotistical is often difficult. It's tough to say, "I'm a fantastic artist and have won countless prizes for my work; I've sold to many important people, and my work is in such-and-such a collection." If you have someone to represent you on the street, it is easier for that person to praise your abilities, but if you're like most artists on the street and act as your own agent, it can be difficult. Unfortunately, art shows prohibit displaying award ribbons from previous shows. Granted, that practice could get out of hand; some might even hang faded ribbons from the 1935 World's Fair. If, however, you were allowed to display only those of the previous year, the customers could see that you were indeed a winner and worthy of consideration.

There is a way out of this dilemma, and that is through a publication that extols your virtues in print. Most people not only believe, but are impressed by, anything that appears in a publication. We are conditioned to accept as fact any printed statement. The more impressive the presentation, the greater its validity in terms of acceptance. A four- to ten-page brochure can do much to convince the prospective buyer of the worth of your product, and of your worth as an artist. The brochure should contain a photograph of you, a favorable comment by someone in a position of authority, a listing of shows and awards, a list of past sales to collectors of prominence, and photos of your work. For the beginning artist without prizes and important sales to rely on, an explanation of your technique, if unusual, or your reasons for doing the type of work you do, can add substance to your brochure. Colored photographs impress more than black-and-white, and if you can include the work you are presently selling, so much the better. The purchasers of your work will gain prestige by being able to point out to their friends the exact pieces they bought as displayed in your brochure.

The cost of such a publication can be high, but if this cost is distributed over the number of works displayed, it will not be prohibitive. As your brochures cost money, reserve them for interested adults who are potential customers. Printing prices can vary considerably, so shop around for the best price. Don't dismiss the use of tip-ins (photographs printed independently of the copy and hand-glued into place), because that method could be considerably cheaper, and it allows you to modify your publication as works are sold.

The third method of developing a following is to turn into your own

public-relations agent. Most artists blanch at the suggestion that they should declare themselves the greatest; but don't tell Muhammad Ali that it doesn't work. Artists will gladly sit for a press interview and be flattered by the attention, but very few actively seek publicity or have developed a plan to achieve fame.

Over ten years ago, a young couple of my acquaintance quit their jobs and declared themselves artists. Recognizing that they were only faces in the crowd, they determined to make themselves known. They realized that to make a success of their new career, they were going to have to use every means at their disposal. They hit on the idea of sending a weekly or bimonthly news release to the local press. Their first one dwelt on their having given up nine-to-five jobs and opted for a new life style. The press found the story newsworthy and gave them a large spread. (Other artists, I'm sure, have made the same decision; but few have bothered to call the public's attention to it.) The young couple then announced through the press their acceptances at prestigious shows, using the shows' advance copy to inform the public of the importance of the show and the honor of being accepted by it. Prizes they won at the show were likewise announced, and their fame grew. Three hundred and ninety-nine other artists had been accepted into the same show, and 29 of them also won prizes; so most artists would figure it was no big deal. It was a big deal to the press, evidently, because they printed the information. It was a big deal to the artists because it brought their names to the attention of the public. They continued to send in the releases, and enough of them were printed so that at the next local show people sought them out.

Every art show you attend is looking for publicity. Shows can dream up their own press releases, but many would welcome a well-written, newsworthy article that they could simply turn over to the newspapers complete with photographs. One major show publishes its own newspaper, which is distributed free at the show. A mention in this publication, which many read, brings customers to the displays of the featured artists.

At a recent major show, an artist appeared the second day to find a man waiting for him at his display. Before he could even set up his work, the man pulled out a clipping containing a photograph of the artist's display, which the show's publicist had taken the day before and the morning newspaper had featured. The man inquired if a certain painting in the photo had been sold. The artist replied that it hadn't. The customer, without questioning price, said, "I'll take it!" He did, paying the artist $700. The power of the press is enormous!

You needn't have majored in journalism to know what is newsworthy. Is this a second career for you, and does the switch from your first seem

incongruous? If you are retired, what did you do before? Is your product in some way different and unique? Do you use tissue paper imported from Bavaria? Have you hit on a technique that is different? Have you dusted off some bygone process and updated it? Sure-fire copy can be made of the fact that you have overcome some difficulty, because the public and the press like success stories. Was your childhood impoverished? Was your art training acquired late in life? Are your paintings the result of a love affair with certain landscapes, horses, the sea, or a process? The list could go on and on.

Most artists, if they put their minds to it, could come up with not one, but a dozen angles that would make good copy. If you are not verbal, perhaps your spouse or a friend is. Hiring someone to write for you is not out of the realm of possibility. Time and energy are required to make yourself a known entity, but the effort is bound to pay off, or billions a year wouldn't be spent on public relations and promotion by major U.S. companies.

HOW TO BE SELECTED INTO SHOWS

By following the procedures as outlined in the show's brochure, and knowing what screening committees look for, your chances of being selected into a show are greatly enhanced.

Your first step is to send for the brochure the show distributes. Do this as soon as you hear or read about the show, because you will want to weigh all options before making decisions. Study the brochure well, as it contains a great deal of information which you can use to determine if the show is to your liking. The awards to be offered are listed. Are they in- or out-of-category awards? If you are a painter and the awards are out-of-category, what are the chances of getting a prize? Much less than they would be if awarded in category. If you're shooting for prize money, you may want to skip this show unless you feel your work can compete with photography and crafts, which lately have been sweeping the out-of-category awards. How many categories can you enter, and how many works must be displayed in each category? How big will your space be, and is there a height limitation? How recent must your work be? Are there restrictions on the type of art that can be shown? (If the show allows offset prints, for instance, and you're a legitimate printmaker pulling your own editions, you can be killed by the competition of the less expensive offset prints.) If there are no restrictions noted, it could be a "junk" show, and you'll be competing with potted plants, antiques, or a carnival. Can you have a proxy sit your stand, or must you be physically present? The an-

swers to all of these questions are usually spelled out and will help you determine if this particular show is for you. The fees will be listed as well as the proper procedure for entering. Don't miss your chances for an acceptance by failing to comply with the procedures exactly as outlined. Also, note the final date for mailing in your slides and entry forms. I've missed out on some shows that I had intended to attend because I let the dates slip by.

In sending for entry forms, it's a good idea to request two copies, even though you will use only one. The reason is that some show applications have vital information on the show printed on the back. Once you have sent it in, you no longer have that information unless you also have a duplicate application form or have made a copy.

As sending for application forms is not a commitment to show, you may want to send for forms for two or three shows being held on the same weekend, so you can compare the shows and select the one you feel will be most profitable for you.

In selecting shows, biggest isn't always best. Your selection will be based on your goal. For instance, if you're shooting for prize money and must choose between a national show and a state show and you know the big competition will be attending the national one, you may decide that the second show will provide a better chance of being awarded a prize. If you're after sales, the national show, with its greater draw, might be your selection.

If the show doesn't demand slides but simply allocates space on a first-come, first-served basis, make up your mind immediately. If you decide to enter, get the fee and form off quickly, because you never know how fast shows will fill up. If the show demands slides, you have until the announced closing date to mail in your information. If you have attended a show regularly for a few years, you may receive an application form automatically without having to send for one. Also, if you were a prize-winner in a recent major show, you may automatically receive an invitation from another show; art-fair committees often visit larger shows and invite the prize-winners in order to raise the quality of their own shows. In the last two instances, you may find stamped across the face of the application NO SLIDES NECESSARY AS WORK IS KNOWN. This message not only saves you the $5 jurying fee, but also lets you know that you've already been accepted; all that is necessary is to send in your entry fee. As this is a courtesy extended by the committee, try to return the courtesy by mailing in the application form and fee just as soon as you've decided to attend. If you decide not to enter, drop a note to the committee chairman expressing your thanks for the invitation and requesting that you be kept in mind for

the following year. As the stamped blank is not transferable, send it back with the note as proof that you haven't passed it on.

HOW ENTRANTS ARE SELECTED

Once a show closes to applicants, the show committee will call together its screening committee to make selections. Occasionally, but not often, the members of the screening committee will be announced. They may be members of the organization sponsoring the show, out-of-towners, non-members, or some of each. This is an important committee, as it will determine the quality of the show. To achieve a balanced show, it will allocate to each medium a portion of the show's total spaces. This is an ideal arrangement, but not always achievable unless the show receives thousands of applications.

There is no set method of doing the screening, but to save time the committee tries to meet and decide as a group rather than make individual judgments. The past year's prize-winners and nonjuried invitations are recorded as accepted. Then four projectors are set up, with one slide of each artist in each projector. The four slides usually include three of his works and one of his display. The committee members run through the applicants, noting "yes," "no," or "maybe." As they review the slides, they may weigh other considerations. Some show application forms have blank spaces where the artists list their shows and prizes of the past year, and this information may influence the committee's decision. Some shows encourage demonstrations to add color to their shows, so an expressed willingness to demonstrate could move an artist from a "maybe" to a "yes." After the initial run-through, the committee selections are checked against their media space allocations. Committee members may find that they have selected only ten sculptors but had space allocations for twenty. A review of the "maybes" will produce a few more sculptors, and the committee will then take the leftover sculpture spaces and give them to a medium—perhaps watercolor—in which there have been twice as many acceptances as there are spaces. The entire list may have to be trimmed or added to, depending on the number of applicants and the spaces available. I have been to shows where the selection committee failed to do its job well, and half of the show consisted of one single medium.

Formerly only one entry fee was collected; those not accepted had their checks returned with their rejection notices. The additional $5 slide-viewing fee caught on a few years ago and has caused some concern among the artists. When entering a show, artists are requested to send their completed application form, the show's space fee, and a separate check for $5 to cover the cost of the screening committee's handling of their entry. This

$5 is not refundable. For the artists who are rejected, it's like taxation without representation; they are contributing to a show at which they are denied the right to sell. The show committees argue that many hours of work go into the operation of the show, and that to prepare for, screen, and mail out the results of 2,000 applications is not a labor of love. They maintain that the $10,000 collected is needed to operate the show, and perhaps to increase the prize money offered. The real beneficiaries of screening fees are the accepted artists, who gain from appearing in a higher quality show brought about by larger prize money. I've never heard artists complain of the nonreturnable fee at a museum-run salon show, nor have I heard complaints about paying this $5 screening fee from the successful street artists who make the shows. Recently, one show gave a report card in return for the $5 fee. The selection committee graded on a ten-point system, based on the quality of slides, work, display, etc. It was a nice touch, and although the rejects probably didn't agree with the grading, an artist bent on improvement could gain tremendously by having weaknesses called to his or her attention. A few shows have dropped the screening fee but jumped their entry fees from $40 to $60. They have turned it around, and are asking the accepted artists to pay the cost of screening the work of the rejects. This may be no fairer than the $5 fee, but at least the accepted artists have an opportunity to recoup the additional $20 by selling their work at the show.

Major shows that charge huge fees, draw unbelievable crowds (as many as 400,000 people in three days), and offer awards in the $10,000 range are big business. Occasionally the artist is taken advantage of by shows which know they can fill. One such show, which draws 10,000 applicants, cashes all checks upon receipt. Someone said this is done in order to be sure none of the checks bounces. However, as the closing date for the show's applications and the mailing of acceptance or rejection notices are over two months apart, the show has use of the artist's money for that period of time. Properly invested, it could return almost enough to give the show its award money. Although they know this, artists by the thousand will still apply for entry, just as they will continue to pay the $5 screening fee. Ethics aren't practiced to any greater extent in art promotions than in most businesses.

How do artists feel about the methods being used to select show participants? Over half seem to think the present method of reviewing slides and *vitae* the only fair way to do it. Another quarter feel that if they have participated in a show for a number of years they should be given preference. They fail to recognize that shows grow in stature and importance, and that their work may not be keeping pace. Less than 10 percent feel that the

previous year's prize-winners should be given preference; the others believe that, as it is a new year and a new show, everyone should be offered the same opportunity to gain entrance. About 15 percent would like to see the prejudging thrown out and shows operated on a first-come, first-served basis. Personally, I can't think of anything that could destroy a show faster.

HOW YOUR SPACE IS SELECTED

Your spot in a show can make the difference between a successful showing and a poor one. If you're new to a show, you probably have no idea where the good and bad spots are. You pay your money and hope for the best. Many shows print programs listing the artists and their locations so that patrons can find the artists they are seeking. They also try to arrange a show so that the media are equally distributed throughout the show and are, consequently, reluctant to have artists moving around the show at random. Some shows, by careful planning, have eliminated all of the bad locations; others have dead ends or disaster areas. At shows I have attended for the first time, I've been placed in hellish spots next to the Jiffy Johns, in an open field with no shade, and in a spot five unusable spaces distant from the rest of the show. When this happens, I usually sweat it out for the first day but try to find a more desirable unused space for the remaining time. At the end of the first day, when it's obvious the space I've spotted isn't going to be occupied, I seek out the show chairman and politely ask if I may change. I've rarely been denied the request. I've seen artists use the opposite tactic and rant and rave, but this approach may not always work. Committees have been known to refund fee money to the screamers and ask them to leave the show. However, committees want a well-run show and are usually concerned with your happiness—and therefore willing to grant reasonable requests.

Your work may demand special considerations, such as an electrical outlet to run your fountains or a shaded spot if you're showing glassed pastels that sweat in the sun. If you need some reasonable consideration, feel free to explain your needs on your entry form. It's easier for the committee to acknowledge your request when planning the show than to try to accommodate you after you've arrived. Once you have attended a show, space selection becomes easier. Most shows have a map with the spaces noted. Save these in a file so that next time you apply, you can make a general space request. Don't be too specific in your request unless you want to return to the same spot you occupied last year. You may inadvertently request a space that is held by a long-time participant and is therefore unavailable. It's better to ask for a space in a general area, and if that

isn't available, an alternative area. This gives the committee greater latitude in meeting your request. As a returning artist you may automatically be given the same spot you occupied in the past. This isn't a guarantee, so it is best to request the area to which you want to return.

Of the artists in the survey, 30 percent have never made a space request. The majority have made space requests and had them honored. Only 10 percent have been denied the spaces they requested.

THE IMPORTANCE OF SLIDES

No single facet, apart from the way you fill out your application, will determine your acceptance or rejection more than the slides you send in for viewing.

I have never discovered why artists who don't hesitate to call a plumber when a pipe bursts will resist using a professional photographer or a skilled friend to get slides that will gain them entrance into shows—shows on which they depend for all or part of their livelihood. Maybe artists figure they are photographers, just as many people fancy themselves art critics. I have prejudged, by slides, a show where a quarter of the artists could have saved their money because the slides they sent were so bad it was impossible to determine the quality of their work. If you use a professional or a knowledgeable friend, here are some suggestions which may help. Assemble sufficient work so that three or four rolls of film can be shot at once, and you will get your money's worth from the time for which you are paying. If you plan on using a slide of a single piece of work to enter a half-dozen shows, take at least six shots of it rather than have copies made by a film processor. It's surprising how often copies are so untrue in color that they don't even resemble the original. It is also worthwhile to go to a reputable processor. Too often, film sent to a "quick and cheap" processor results in poor-quality slides.

If you are a competent amateur photographer, here are some other suggestions that may prove useful. If you shoot indoors, make sure the type of lighting you are using is compatible with your film. Tungsten light requires a different kind of film than ultraviolet light. Use two floodlights at 45-degree angles on either side of your artwork for even lighting. Don't use a flash, as it causes harsh shadows. It is simpler to move out of doors, where you'll encounter fewer problems. Try for an overcast day, or at any rate don't shoot at high noon. Select a good quality, slow-speed slide film. This advice holds even if you are shooting black-and-white objects, as poor film can make white areas look blue or red. Always use a tripod.

In shooting two-dimensional work, make sure your camera is pointed at its center and that the film plane is parallel to the plane of the artwork.

Don't try to shoot through glass, as you'll end up with "hot spots" of reflected light or your own reflection. Move in close enough to fill the frame with the artwork in order to eliminate distracting backgrounds; for irregularly shaped work, block out unwanted background areas on your slide with silver photographer's tape. Don't use masking tape, as it can cause the slide to stick in the projector. Use the proper exposure so that the slide will be neither too dark nor too light, and to avoid blurred pictures, refocus every time you move the camera.

In shooting three-dimensional work, keep your background simple and effective. Remember you're showing off the artwork, so don't destroy it with a backdrop that's too busy or colorful. Shallow depth of field can blur a background nicely and can be accomplished with a telephoto lens or, for small work, a macro lens. However, if the depth of field is wafer thin, part of the object may photograph out of focus. If the artwork is white, a dark neutral background is best; if the piece is dark, a white background will give you the best contrast. Some artists vary the exposure in a series of slides of the same object, to cover the wide range of possible color intensities and development of detail.

Do your camera work a month ahead of any deadline so that you aren't forced into such expediencies as taking your film to an overnight developer or putting yourself through the agony of a midnight mailing in the hope of making a deadline. If your slides turn out badly, don't send them with an explanation for their failure. The screening committee doesn't care that the cat climbed your leg just as you were taking the shot. Send well-photographed older work if you must seek a replacement. At the show, committees may check the work being shown against the slides you submitted, but if your newer work is superior to the slides, they probably won't order you out of the show.

THE SHOW

Organizing for and attending a show can be a hectic experience unless you have a system that will help eliminate some of the confusion. I would like to take you through a show experience and offer some suggestions which may be of help.

Once your acceptance arrives, you can decide what work to take and start preparing. Each show has its own peculiarities. What will sell will vary from show to show, even within the same town. If you have kept records of your previous attendances at a certain show, a review of your sales records may give some clue as to what work and what price range will give you the greatest potential for sales. One show I have attended over the years has proved to be a volume show, with most sales being made on

works priced $50 or under. At a different show only 30 miles distant, I've consistently sold higher-priced work, but less of it. Dollar sales at both shows are about even. I try to take both price ranges to each show, but I concentrate on what my experience indicates is most likely to sell.

Be prepared for the show as far ahead as possible. You don't want to be forced into last-minute purchases of materials from non-discount sources, which can raise your costs.

As it is easy to forget items, use a checklist when loading your vehicle for a show; go down the list to be sure you have everything. I've seen artists arrive at a show only to discover that they have left at home work they were counting on to win the prize money. Bringing your own tools to erect your display is quicker than seeking a fellow artist who is willing to lend you what you'll need.

Set-up time the first day of the show is hectic. There are 400 artists trying to park in 200 spaces near their displays. The streets are congested, traffic slow, and tempers short. If you have the time and money, and if the show is at some distance, make it easy on yourself and try to arrive at the site the evening before the show. Some shows will allow you to put up your displays that evening, which relieves you of the morning hassle. Even if this is not possible, you will be able to get a good night's rest before the rat race.

Always check in at the registration desk before unloading. I recall the time I had unloaded, set up my display and hung the work, and was then informed that my space had been changed to one three blocks distant. As it was impossible to reload, I had to tear down and manhandle my entire display to the new location. Once you have found your space, unload your display and artwork, and then move your vehicle to the designated parking area. Don't set up as you unload; that only adds to the congestion. Also, don't violate the rules and park in the area reserved for customers. I know of two shows that have poor attendance and sales because all the parking spaces near the show are taken up by artists, and the customers refuse to walk the five blocks to attend the show.

Adding to your anxieties is the fact that judging is done the first day of the show. Be sure you set up in time and have your prize-winning efforts prominently displayed in an uncluttered manner.

As noted earlier, most shows will allow you to keep your displays up overnight, and in some instances even your work, if security is provided. The decision is up to you, but I rarely leave my more expensive work at the display overnight.

Set-up time the second day of a show isn't usually difficult because the displays are already erected; most artists have no trouble reaching and

parking next to their displays. At major shows, crowds will start arriving before the show officially opens, but at most other shows there is usually a leisurely hour or so in the early morning. I use this time to walk through the show and see the other displays, talk with friends, check on sales, and find out who won the prizes. I can do this and still make it back to my display to greet the first customers.

Break-down time can be another harried period because all artists try to leave as soon as the show closes. There being no pressure at quitting time, I personally load up at a leisurely pace. The half-hour I lose by not being the first one out is more than made up for by saving damage to my nervous system. It is as good an idea to load carefully and systematically for the trip home as for the trip out. Poorly packed work can shift and can cause extensive damage.

As soon after a show as possible, review your sales sheet, send in the state sales tax, figure costs and (I hope) profits, and be sure that any information relative to motels, restaurants, and patrons is recorded for future reference. If you don't do your accounting immediately after a show, you may forget why you recorded a certain phone number or why someone's business card is in your wallet.

5

KNOWING YOUR CUSTOMER

If you know who are the buyers of art and what their preferences are, it is possible to orient your product toward sales, or to select work from your existing stock that has a good chance of being purchased. However, I am in no way implying that the quality of product be diminished to meet public taste.

The average artist surveyed didn't give the customer much credit for understanding art, and noted that only a quarter of the customers are well informed. The artists in the upper 3 percent in sales rated the art knowledge of customers much higher, estimating that at least half of their customers are well informed. This would seem logical. In selecting an artist's work, the customer is reinforcing that artist's belief in what constitutes art; thus, the more you sell, the more prone you will be to credit your customer with informed decisions.

If the percentages are correct, most art buyers are not very knowledgeable and they fall back on the old saying: "I don't know anything about art, but I know what I like." These percentages should also indicate the importance of educating the customer to your product and to your worth as an artist. Promotion and selling also gain importance, and so does a striking presentation that will lure the customer within talking range. The customer can't like your work unless he or she sees it.

WHO IS YOUR CUSTOMER?

Granted, everyone buys some art, but there are segments of our culture that account for a disproportionate number of purchases. They are middle- to upper-middle-class people whose incomes allow them to spend money on things beyond the basic necessities of life.

Major art purchasers are in the middle age-groups, ranging from their mid-twenties to early fifties. Until their mid-twenties, most people will not have established roots. These younger people may be students whose money must go for education, or they may be so involved in pop culture that fine art does not play a large part in their lives. When people have passed their early fifties, they are winding down; their children are grown, and they are more apt to be disposing of their homes and possessions than collecting. A noted exception would be retirees moving to a new geo-

graphical location and embarking on a different life style that demands decorating a new abode. The group beyond their mid-fifties may continue to buy art, but on a much smaller scale. They are not generally a market for major purchases unless they are collectors.

Your art purchaser is better educated than the average American and more apt to recognize the practice of art as a profession rather than recreation. You can't "hustle" educated people, but they are more willing to listen to you and more capable of making intelligent decisions.

According to the survey, men buy only 10 percent of art by themselves. It seems we are still caught up in role-playing in America, despite the unisex push of the past few years. Men consider themselves macho; they are involved in sports and automobiles, and they stay away from the ballet, concert music, and art, which they consider feminine activities. Sensitivity is still considered a weakness by the average American male.

Women, on the other hand, have long been regarded as the repository of culture in our society, and it should be no surprise that women account for half of art sales. Men and women buying together are involved in 40 percent of sales, and, if my experience is any indication, women are usually the decision-makers when couples buy.

Your type of product and its price also determine who your customers will be. Low-priced jewelry has a wide and ready market among all age groups. Expensive paintings have a narrower market, and they're usually purchased by young to middle-aged professional people. The market for prints is wide in the lower-priced range, but narrows as prices increase. It is for this reason that I show and sell at a wide range of prices, from small $7 matted serigraphs to large $200 etchings. Low-priced functional pottery has a wide market, while larger, more expensive, and esoteric pieces are in less demand.

You will find that some sales are easier to consummate than others. Perhaps the easiest sale to make is to the single individual, as you become the customer's *confidant* in the purchase. You can allay fears, and convince the customer of the correctness of his or her purchase without outside interference. The second easiest sale to make is to young couples, just going together or recently married, because their relationship is still at a giving stage. Although one member of the couple will be the first to express interest, the other is usually willing to go along: "If you want it, Honey, let's get it." The fact that young couples are usually short on cash and consequently buy the lower-priced item may also account for the ease of the sale.

Next in increasing difficulty would be two members of the same sex, such as a woman and her friend who are attending the show together. Al-

ways sell first to the one expressing interest, but never neglect the other for too long, because the buyer will inevitably turn to her friend and ask, "What do you think?" If you have made the effort to involve the friend and to flatter her by paying her some attention, she is more likely to reply in the affirmative than if you have totally ignored her existence. As no two people have the same tastes in art, you might in this instance digress from the item in question when talking to the friend, especially if her attitude is noncommittal; compliment her on how well she is holding up under the pressing crowds, or whatever seems appropriate. You may not be able to sell the friend on the artwork being discussed, but you can sell yourself; and so when the question is asked, "What do you think?" the friend, mellowed by the attention paid to her, will be more inclined to go along with the sale. A man-and-woman combination will also fit into this category if they are considerate of each other.

The most difficult sale to make is to a husband and wife who have been married for some time, and whose interests differ. The wife may have a serious interest in art, but her husband is attending the show under duress. He was probably pulled away from his golf or a ballgame, and is consequently in no mood to compromise. Special effort must be made to woo the husband because the wife is going to buy anything she is allowed to buy, but your sale will depend on his acquiescence. I only give this type of sale a fifty-fifty chance because it depends entirely on the ability to break down the resistance of the husband.

Customers with artwork under their arms are good prospects for a sale, as work already in their possession means they are in a buying mood. Ask to see the work they have purchased, if it isn't too securely wrapped. Positive comments on their purchase will flatter them, and you can also take the opportunity to assess their art preferences. Knowing what they like will allow you to point out similarities to your own work as you push for a sale.

WHAT DO THEY BUY?

Some readers will be turned off by my pragmatic approach to what sells, but I am being utterly truthful, and I would fail in giving you the information you want if I didn't call it as I see it. As women are involved in 50 to 90 percent of the art sales, it is obvious that, if you plan to sell well, your work must appeal to women. Women buy art to decorate their homes or, in the case of jewelry, themselves. What factors are instrumental in their purchases?

The most important factor in two-dimensional work is color. No matter how great your work is, if the color clashes with the decor of their homes

they will not buy. I thought I had the final solution to the problem of what colors to use when I read in the newspaper a few years ago that a well-known paint company had compiled a list of the ten most popular interior paint colors. I eagerly wrote the company for the list and their color chart. Do you know what the ten most popular colors were? All ten were white, running from warms to cools. White sells not only in paintings, but in pottery, prints, and you name it. White is universally acceptable, as it is the easiest color with which to decorate.

Your choice of the other colors you use along with white can be all-important. In trying to ascertain the colors that are used in today's decorating, the publications that deal with home decoration are little help. The magazines try to stay ahead of the times and are usually only an indicator of what will happen two or three years hence; they tend to be avant-garde and a bit far out in terms of the colors actually being used. My advice is to visit a number of furniture-store showrooms and make a list of the colors most commonly in use.

Color choice is regional, and the bright yellows, lime greens, and off-whites of Florida will not necessarily sell in Butte, Montana, where colors may run to the earth tones. Also, tastes in colors change. What is "in" this year may be out of vogue three years from now.

Your artwork being an accessory to the decor, screaming high-intensity colors that will draw attention away from the $400 couch will sell less frequently than muted tones of these same colors. When I first started doing silkscreen prints, I attempted to touch all bases and turned out a number of prints which featured primary and secondary colors in varying values. I've sold out of the soft oranges, the beiges, the browns, the greens, and the quiet yellows. I still have drawers full of prints featuring purples, blues, and high-intensity reds.

Don't try to become the customer's decorator. I realized that I was doing just that when I used colored mats on my prints. If a print was done in blues and greens, and a blue mat was used, it killed the green so that only persons looking for a blue accent were interested; if matted in green, only those decorating in green were interested. By using a white mat, I allowed the customer to consider either color as an accent, and the print's sales potential was doubled. As people see what they want to see, don't try to dictate what they will see.

Of second concern is subject matter. Totally abstract, nonobjective works sell only to customers who have some knowledge of art. I and others I know have sold abstract art on the street, but it has been a very small percentage of total sales. Your average sidewalk buyer may have heard of Franz Kline, Hans Hofmann, or Robert Motherwell, but chances are that

only a very few either appreciate or understand their work. Work that contains recognizable subject matter is going to be more negotiable than nonobjective work, and that should be a factor to consider if you plan to sell your art rather than merely take it out for an airing.

Another warning: don't plan on selling great amounts of work depicting team sports such as hockey, baseball, or football. You will be limiting your market even more than with abstract art, as your appeal will be only to the 10 percent of purchasers who are males. Individual sports that the customers are likely to participate in, such as golf, tennis, jogging, and swimming, will fare slightly better. A few years ago I hit on the idea of doing surfing paintings, and I turned out four in the hope of capitalizing on the interest in that sport in my area. Although interest in the paintings was high, I sold only two; both, incidentally, went to women who bought them for a son and a nephew. What I didn't take into account was that surfers don't have $80 to spend on a painting, no matter how appealing it might be to them.

What subjects are most popular? Mother-and-child depictions have a great appeal despite our concern with zero population; children are popular, dancers, and women both clothed and subtly nude. Scenes of tranquility and happy, upbeat paintings have the edge over a well-painted dead chicken. Scenes that depict elegant bygone eras are marketable. There is a painter who has made a career out of painting weathered barns in warm autumn colors.

A former student's paintings, which were of opulent women reclining on baroque settees and surrounded by flowers, were in such demand at $200 per painting that she couldn't keep up with the requests.

Scenes of local interest, especially if there are many tourists in your audience, will usually do well. In my area of Florida, beach scenes, boats, the Everglades, pelicans, shore birds, or anything of local interest will sell over a snow scene. What you choose will depend upon what part of the country you reside in, and what the people there find of interest.

Topical subjects have appeal but may not last over a prolonged period of time. A sculptor hit it big with seagulls when the book *Jonathan Livingston Seagull* was at its height of popularity. Another artist capitalized on the movie *Jaws* and did a print of a shark attacking a maraschino cherry in a cocktail glass. Walk through any major show on its second day and check the half-empty displays to apprise yourself of what is selling in terms of subject matter and color.

This analysis deals with two-dimensional art, and in some instances, sculpture. In the crafts area, utilitarian works outsell nonfunctional items. Someone who wouldn't consider buying an abstract painting will go for a

very contemporary ring or necklace because it is a useful object. If your craft contains color, the remarks on color selection apply. Price and quality of craftsmanship seem to be more operative in the marketing of crafts than in painting, where a terrible painting of a popular subject, in proper colors, will sell over a well-executed work that lacks those characteristics.

For sales, the third factor in importance is artistic value. It may seem treason to place art after color and subject matter, but you must remember that we're discussing sales, not ideals. It would be too utterly perfect to be able to do your thing and find an insatiable market for your product. There are those artists who profess to do just that, but few top-selling two-dimensional artists refuse to concern themselves with popularly acceptable color, subject matter, or both. I know of an artist who paints abstracts and does quite well with them despite their limited customer appeal. She does, however, keep two-thirds of her canvas white, and for the rest she uses the popular earth colors. Her appeal is in the color, and I doubt if she would sell any of her abstracts if they were done in purples. A superior watercolorist gets by with works using the not very popular cool palette, but balances that with the popular subject areas of landscapes and boats. Artistic quality as an ingredient in your work can replace either popular color or popular subject matter, but not both in the same work.

In a craft area such as jewelry, where neither subject matter nor color plays a leading role, one would think that the artist would have greater freedom. In this medium, however, artists must stress utility if they are after sales.

I am in no way implying that you can ignore artistic worth, because most people can tell the difference between a well-crafted piece and one that is poorly made. Those artists who are high in sales combine a superior product with popular subjects and colors.

TURNING CUSTOMERS INTO PATRONS

If you are making either a full-time or part-time career of art fairs, you will undoubtedly repeat shows. A customer once satisfied is a prime prospect for a future sale. Although I have had customers repeat year after year in purchasing small items, there is usually a time lapse of at least a few years between major purchases. Once a customer has repeated, make a special effort to woo that person, who is now a collector of your work. Everyone likes to be important, and a repeating customer feels like more than just a customer. The customer has become a patron of the arts and is keenly interested in his or her role and your success. You can bet that any conversation you have with such a customer, in which you praise his or her selection, will be repeated to many people who view the work of yours

that has just been purchased. You are "his" or "her" artist; your customer creates through you, and values your relationship. If you have the ability to recognize that person by face and name when you meet, the barrier between seller and buyer is broken down. You become friends, and, as everyone knows, it is much easier to sell to friends.

Artists with customers who repeat on major purchases should try to maintain contact. I know some who send Christmas cards. Others drop a post card and inform their patrons when they will be attending a show in their area. Some even send slides of new work which they feel might be of interest. Another artist sends an annual letter informing the customer of the prizes he won in the past season, and the current value of his works that are in their possession. As patrons are collecting your work, they are delighted to find their purchases appreciating in value. You, as a creating artist, are expected by your patrons to grow, and your work is expected to change. But patrons want the change to be gradual. They are not equipped to handle dramatic shifts in style or medium. This can be a dilemma if you find yourself in a rut and feel that drastic measures are called for. Change if you must, but expect to lose some of your following.

I know of one printmaker who produces his prints in sets of about ten to encourage collectors. The entire set is of greater value than the ten individual prints, but he sells the set for a lower figure than the ten prints would bring if bought separately. Another printmaker does much the same thing, but there is no definite number to the series. For the past several years he has turned out three new prints annually that are thematically consistent with his previous output. Some of his customers have given him standing orders for his new prints as they are produced.

Of the artists surveyed, 30 percent have developed patrons who have repeated on sales. Another 22 percent have made sales on referrals from satisfied customers.

Lest you misinterpret my pragmatic concerns with art as a product, I must again state, as I did at the beginning of this chapter, that you cannot, and never should, consider lowering your standards to meet a market. However, I must ask: Was Rothko a lesser artist because of his soft colors, or De Kooning, because of his warm palette? Van Gogh did portraits; Durer, rabbits; and Goya, bullfights—but did their subject matter diminish them as artists? It's not so much what you depict as how you depict it that is going to determine your worth as an artist.

6

YOUR PRODUCT

Three areas demand your concentration if you hope to become a successful art-fair artist: your product, your presentation, and your sales approach. As the last two areas will be covered in following chapters, we will focus here on your product.

Without a product you have no reason for being in the marketplace, and without a saleable product you have little chance for success. Many of us hit the street because we have a backlog of work for which we have not found a marketplace. The work may have been done to fulfill requirements for undergraduate or graduate degrees, or it may be an accumulation from personal involvements with various areas of art. These accumulated works may have been sufficient to launch a career at art fairs, but in a very short time we found that this body of work did not make for super sales. We were soon forced into making a very crucial decision: should we adjust our product to the marketplace and hope for better things to come, or should we abandon the street and hold to our lofty but unprofitable ideals?

HOW FREE ARE YOU?

Fellow artists have watched me over the years as I've adjusted my product to make it more desirable to a greater audience and, consequently, more saleable. They have thrown up their hands in horror and decried my efforts, lamenting over the loss of what they considered my artistic freedom. My answer is to take them to my studio, where I have rack after rack filled with paintings that are considered my better efforts of the past twenty years. I explain that I don't have room for any more "great art," and that if they know of anyone who is looking for some, to please send them around as I have enough to decorate the Louvre. As my artist friends are admirers and not purchasers, I see no benefit in producing work that will only add to my storage problems. Possessing the egomania of most artists, I know I can create significant art, but to create good art that finds a market is a challenge that demands thought, planning, and testing, and which may meet with either success or failure. It is conclusive, and I needn't fret over whether some future art critics will find it valid. I do not see myself losing

any more artistic freedom through my present course of action than through any other.

Realistically speaking, few successful artists have total freedom in what they do. Galleries, agents, critics, and museum directors all have criteria that must be met if you are to succeed, and artists who plan to become successful must recognize these criteria and comply. With the Madison Avenue approach to the promotion of art, it is more than likely that unless you are willing to make some compromises, you will remain obscure.

IS IT ART OR A PRODUCT?

Perhaps one of the more significant bits of knowledge gained as a street artist is that great subjective art, born of sweat and agony, is not a major factor in street sales. What is important is a product that meets the public's needs, can be produced without excessive cost in time and materials, and can therefore be sold at a profit.

Possibly some who have purchased this book are offended by my calling art a product. The word *product* does not appear in the survey I made because at the time it was done, my thinking was not clear on what constituted success at art fairs. My sales at that time, low to average, will attest to that fact. As I explained earlier, I undertook the survey out of a selfish desire to see if there was a formula for success. It was only after compiling the survey and giving the results considerable thought that I realized I was actually in a business. Before that, I had thought of myself as an artist concentrating on my own personal development. I went to the art fairs because I knew that was where people bought art. I was concerned with peer acceptance, not buyer acceptance, and although yearning for sales, I was reluctant to make the concessions that would bring them. As I look back on that period and recognize the subjectivity of my work, I realize that only fellow artists knew what I was trying to do. Few buyers understood what I was attempting. Even judges, from whom I expected understanding, favored me very infrequently.

As soon as I recognized my problem and switched my thinking from art to product and presentation, my sales jumped considerably. I feel that what I am doing now is no less artistic than what I was doing previously, but audience acceptance has greatly improved. Not only have sales jumped, but prize money has increased by an even greater percentage. Why? Because judges are only human, and they are as affected as the general public by quality of product exhibited through craftsmanship and display.

Only 31 percent of artists who had formal training in art thought their training was of extreme benefit. That leaves about 73,000 formally trained

artists who feel they have been to some degree shortchanged by their education. Implicit in these figures is the fact that the end product of street art differs from the goals pursued at most art training institutions. This is obvious if you contrast the quality of the work in any major regional or national competitive salon show with even the better sidewalk shows.

You will find work that is avant-garde on the street, but the percentage is small, perhaps no greater than the 3 percent who profess going to shows for prize money. By avant-garde I mean work that acknowledges current trends and techniques, is contemporary enough to be recognized by museum directors as making a contribution to the development of world art, and for this reason is considered of "museum quality." In the last national print show I visited, I recognized the work of only three street artists in the 250 selected works. There are undoubtedly many street artists capable of producing art at this level, but there is no financial profit in it. The 27 percent of street artists who make their entire livelihood from street sales do not have the leisure to overly intellectualize their art, or to struggle with a concept over an extended period of time with the distinct possibility that their efforts may end in failure. The street artist, to survive, must work toward a product that has public appeal—and, having arrived at the magic formula must exercise the discipline necessary to repeat that image as long as it stays marketable. When the appeal lessens, the artist must be capable of making the changes necessary to keep him on top.

The street-art public is interested in a product and is not concerned with, or willing to pay for, your struggle to produce masterpieces. The fact that you put a year's time into one major work of art is not going to increase its street value to such an extent that the art-fair customer will pay you $20,000 for your effort. Those with $20,000 to spend on art will go to New York, where their investment in a major "name" artist will have a greater likelihood of appreciating. The buying public is out there with established likes and dislikes which you, as an individual, are incapable of changing to any great degree. You must adapt your product to the public's likes if you hope to succeed in sales. I am not advocating producing bad art; I'm advocating producing good art that sells. One of my great delights is to have a customer walk off with what I consider an excellent painting, even though she may have bought it for reasons having nothing to do with its excellence.

It takes a mature person to judge himself or to accept the judgment of others. In the case of the street artist, the buying public's rejection or acceptance of his work is a judgment. If rejected, he must take the steps necessary to correct the lack of interest in his product. If his art becomes too precious and he refuses to adjust, he is doomed to failure. I have seen art-

ists refuse to sell a print to a customer because that person happened to mention that he planned to hang it in his bathroom. Art is not a child to be protected and cherished by its creator. If that is your attitude, it is best not to go into street art. You can be high on your work—in fact, you should like it if you plan to sell it—but sell it you must if you want to survive as an artist.

Most artists are working to the best of their abilities. Less than their best will not do. I know, as I've cynically tried to turn out what my findings indicated as the totally saleable painting. I've selected the proper colors and subject matter, and attempted to ignore elements like composition and surface, which my selling experience indicated were of less concern to the customer. I succeeded, but the work was a failure because it fell so far short of my standards that I refused to show it.

A few years ago I took a labor of love out on the street. It was a painting I had thoroughly reworked at least three times, spending a month in its production. Considering the time involved, my price of $600 was low. I did receive an offer from a young couple at the last show of the season for half that amount, but I refused to sell at that figure. In retrospect, I see I made three horrible mistakes. First, I refused to sell to the young couple, and thus lost the possibility of a future sale to them or to someone who might have seen the work in their home. Second, I let professional pride and my liking for the painting interfere with a sale; to me, it had become art, not a product. Third, my price was based on the four weeks' work I had put into the painting, and I was asking the customer to pay for the two unsatisfactory versions that preceded the final success. What I should have done, when I produced the satisfactory version, was to turn out ten similar paintings which could have been done in one-fifth of the time of the original, and priced them at $250 each. This was work of which I was proud. Only my short-sightedness kept it from becoming someone else's pride. It's too late to sell to the young couple, but as other people as well were turned off by my price, I have an indication of the potential marketability of the work. I can put my knowledge to work for next year's shows.

Elitists, who disdain the street scene and have never met those who sell there, consider street artists frauds and prostitutes simply because they sell their art. They fail to look past the selling, and at the art itself. There are some great artists showing on the street—artists who, with proper backing and promotion, would rival many of those whose work is being shown in national galleries and contemporary museums.

Almost one-third of the artists surveyed display the best work they are capable of producing and refuse to show what they consider to be less than a quality product. Another 60 percent balance their offerings be-

tween saleable art and their best work, and only 10 percent claim to put saleability ahead of quality. Street artists possess integrity but are also realistic enough to recognize that in order to live they have to sell, although they would much prefer to sell their better efforts. To create a marketable, quality product is the goal of most art-fair artists.

THE COMPETITION IN VARIOUS CATEGORIES

If you haven't won top money in your category in your last ten outings, if your sales are only average, and if you failed to get into the major shows during the past year, it's a safe assumption that you aren't one of the top artists. If you aren't, you have two options open to you. One is to study and work to improve your skill, your imagery, and your offerings in general. The other is to switch to a category where competition is less fierce and acceptances are easier to achieve.

The show scene is continually changing. A number of years ago, a major Florida show had only three potters among the 300 participants. Ten years later, this same show had over a hundred potters due to the growing interest in that area among both customers and artists.

There is no disgrace in changing categories. It is simply good business. I personally have changed from paintings to prints. The transition was relatively easy, and it doubled my sales. Granted, I spent some time learning new techniques, but my knowledge of color, composition, form, and line were transferable from one medium to another. I know of a printmaker who has switched to watercolor, and a craftsman who is now doing sculpture, who have had equally satisfying results.

How do the media stack up in terms of competition for entrance into the major shows? Ten years ago you couldn't give watercolors away at a street show, but since that time they have caught on. Watercolor is one of the toughest competitive categories today. You've got to be a superior watercolorist just to get into the shows, and your work must rival Winslow Homer's if you expect to win prizes. Part of this change is due to the excellent watercolor workshops offered around the country. Watercolors sell in all price ranges.

Sculpture is much less competitive. Sculpture can be large, heavy, and difficult to display. The physical stress turns many sculptors off street exhibiting. As there is currently a big demand for sculpture in galleries, many sculptors can place most of their efforts through this marketing outlet. The buying public seems to prefer the more traditional works in stone, wood, and cast bronze, and shies away from welded steel, plastic, soft sculpture, or environmental works constructed at the site and documented photographically. These latter four do frequently come into prize money.

Small sculpture sells at respectable prices. Large-scale works are in less demand.

Drawings are fiercely competitive, especially in the area of prizes. The work that gains greatest acceptance is more classical than expressionistic. Because of the amount of time that must be put into each drawing, prices are high and sales minimal.

Printmaking, because it is usually lumped with drawing under graphics, is tough in the award category. It's not too difficult to gain show acceptances, and sales are good at all price ranges. The public has been sold, over the past ten years, on the value of purchasing prints. The idea has been stressed that if you can't afford a painting you should buy a print by the same artist; it will be less expensive, and its value will climb with the artist's fortunes. This idea may have been oversold, because customers now will purchase a print at $300 but refuse to expend a similar amount for a painting of the same size by the same artist. I'm not contesting this phenomenon. I simply capitalize on it, achieving greater sales and realizing a much higher percentage of profit. Any art that demands specialized equipment is usually less competitive. Almost anyone can afford a set of paints, but not everyone can afford, or has access to, a printing press.

At one time, painting was one of the more competitive areas, but this is no longer true. With more colleges and universities offering a wide curriculum including crafts and photography, fewer students are going into painting; and at shows this field is swamped with amateurs. Also, many professional painters have turned to other areas where the financial rewards for the time expended are greater. Barely competent painting will get you into most shows. The big prizes go to contemporary work, but when it comes to sales, it is the reverse—conventional paintings sell better than the more avant-garde work.

Photography has made it big in the past few years. More and more photographers have been getting into shows and winning big money. Sales, however, seem to be only average, with low-priced work selling best. Competition is stiff, and you have to be doing exceptional work to gain entrance. Top prize money goes to the more innovative work.

The field of ceramics has boomed and become highly competitive. Your work has to show unusual quality just to gain acceptance, and highly unusual quality to win money. Sales of functional work are very good, and the better ceramists usually do well.

Jewelry likewise has boomed and is also highly competitive. Very competent, innovative pieces are necessary for getting into the shows. Prizes go to exquisitely crafted major works with prices that few can afford. Sales are great on the lower-priced items, and most jewelers realize sales that

any street artist, in any category, would envy.

Fiber crafts such as weaving, macrame, and batik have a public appeal, selling well in the lower and medium price ranges. Crafts, excluding ceramics and jewelry, usually constitute less than 10 percent of most shows, so competition is strong, especially in the more traditional areas. You've got to have a solid product to succeed, and as you are competing with jewelry and ceramics for the prize money, you must have a superior product just to be selected for judging.

There are other craft areas, such as toys, brooms, string art, stained glass, blown glass, dolls, enamels, and countless others, that can do well in sales. Top prize money in these other craft areas is rare, but sometimes it's awarded. Entrance can be gained on the uniqueness of your product, with quality playing a lesser role, as show committees try to have something for everyone. If you are the only one freezing bees in plastic and grinding it into baseball bats, you'll probably be accepted.

What I have been describing is competition at the national show level. As shows diminish in stature, the competition for entrance lessens. Competition for prize money remains high, for even at the local shows there is usually some outstanding work in each category.

There are 22 percent more artists working in the fine arts than in crafts. There are only 4 percent more artists working in the two-dimensional media than the three-dimensional. A walk through any show will give the artist an idea of what areas seem weakest, and consequently offer the best chance of being accepted, which is the first requisite to selling.

REWARDS OF INNOVATION

In world art today the innovator gets the reputation and rewards. Pablo Picasso's reputation was based, in part, on the fact that he was the cofounder of Cubism. Marcel Duchamp's whole career was based on his being one of the initiators of Dadaism. If Hans Hofmann had been in the second rather than first generation of Abstract Expressionists, his work might have gone unrecognized. Thus, highly original or innovative work that is not being done by anyone else has the edge in being accepted. Unfortunately, rewards based on innovation are short-lived for the sidewalk artist who comes up with a new image or technique. If he is successful, he can almost bet that next year he will be competing with ten other artists who have recognized his success and adopted his style or technique as their own, hoping to duplicate his sales. A number of years ago, a few sculptors began working in copper, doing either figures or tableaux. They were very successful. A year or so later, the number doing copper sculpture had multiplied fivefold. With more sculptors entering the field, com-

petition became greater and a minor price war resulted. To sell for lower prices, some artists diminished the quality of their product. Those sculptors who couldn't or didn't want to meet the competition by lowering standards dropped out, and once again, most shows have few sculptors working in copper. The only way you can protect your style and continue to exploit your innovation is to do work that is far superior to your imitators.

SLANTING TOWARD SALES

As a youth, I aspired to become a cartoonist. I sent off for a mail-order pamphlet that was to give me all of the insights necessary to break into what was then a profitable profession. I remember little of what was in the pamphlet except for the section devoted to slanting to your market. By "slanting" they meant that if you planned to sell your cartoons to Standard Oil's house organ, somewhere in your cartoon you had better show a sign that said: "Standard Oil." This advice, so succinctly offered, is still true.

Plan to concentrate on a specific market and give that market what it is looking for. I maintain that the artists who do well in art fairs are those whose work appeals to women, the greatest percentage of the art-buying population. However, there are also smaller markets that, when properly tended, can turn into sales. With 400,000 people walking through a three-day show, what percentage do you think would be involved with the medical profession, law, or transportation? A retired airline pilot I've met made a set of humorous drawings dealing with the foibles of the airline trade, and sold all he could turn out to pilots, stewardesses and other airline personnel. A sculptor in copper depicted various professions in his work. He had doctors, dentists, lawyers, teachers, nurses, as well as other professions and their various branches. The professional people themselves bought, but most sales were made to families or friends of professionals, to be used as gifts. Professionals will buy art. Have you ever been to a lawyer's office and not seen a Daumier print on the wall?

Besides the professionals, to what groups can you slant? Good prospects include hobbyists, game-players, collectors, and any other group with pride and interest in a particular job or activity. I've done very well with a series of prints depicting dancers. Half of the female population of the country have been exposed to dancing lessons as children. They must have fond memories of this experience, as they do buy the prints. Degas did well with the same subject matter. A friend who did some prints of derelict automobiles received so many requests for specific subjects from antique car buffs that he has made these prints his exclusive product.

In slanting, there are two things to consider. First, know your subject. You won't sell to sailors if the sails and rigging on your boats are not accurate, nor to chess players if your chess table is set up incorrectly. Your errors will surely be called to your attention. Secondly, don't make the mistake I made with my surfer paintings, and go after a market that doesn't have the resources to purchase your work.

REPEATING YOUR SUCCESSES

At a recent sidewalk show, a young artist who knew I taught at a university asked me to visit his booth, look at his paintings, and advise him on how to become a "serious artist." It wasn't until the last hour of the last day that I managed the visit he requested. When I arrived, there were only three paintings left on his display, and he informed me that he had sold the other 27 he had started with. In fact, our conversation was interrupted while he sold two more. As his prices were in the $100-plus range, his take for the three-day show was close to $3,000. He had selected subject matter (the Everglades) that has a popular appeal in Florida, and he was doing a better-than-average job of painting. He handled the medium well and was innovative within the confines of his subject. He had the potential of going beyond his present development, but as his livelihood was dependent upon sale of his work, I told him that since he was doing better financially than 97 percent of the other artists there, a change to more serious work might mean a drastic loss of income. There are artists whose work is much more contemporary than this young man's, but they are lucky to see sales of $3,000 in a year.

If you are selling well, stay with a winner. If not, change your style, your color, your imagery, your medium, or whatever else is necessary until you find a successful formula. Once you have found a product that produces a better-than-average income, back off from making any drastic changes. You can continue to improve your product and to run some tests on these improvements without changing your overall sales. If you are showing thirty pieces, you might include three of improved variations, but for the rest, stay with the work that has proven successful until such time as you feel that your new work can increase sales. If your test products sell before all others you are displaying, a change is in order.

A sculptor friend, who was doing figures that sold well at $25 each, felt that he was missing out on the wider market he might enjoy if he also had some $10 pieces. He started doing miniatures of his successful figures, and they did find acceptance at $10. However, while the price of his miniatures was less than half that of his large figures, they could not be produced in half the time, and he found he was working harder for about the same

money he had realized on the more expensive items. The lesson he learned is not to change from a proven product until you are sure that a change is not only necessary, but profitable.

PREDICTING WHO WILL BUY

A number of years ago, when I was showing abstract art at the fairs, I used to amuse myself by looking down the street and trying to pick the type of person who would pause to look at and perhaps eventually buy my work. Because of my idiom and price, I looked for well-dressed, obviously well-heeled middle-aged professionals and for recently married young couples. I got quite good at predicting where my market lay. I was not alone in this game. Other artists do the same thing. When I changed to selling prints, which had a much greater price range and a wider variation in subject matter, my potential customers became more difficult, if not impossible, to predict. Suddenly, everyone became a prospect and as a result, my sales increased.

If you can predict exactly who your next customer will be, you may be too narrow in your product's appeal or price. I'm not suggesting that everyone have $10 items to sell, but if your top figure is $600, you may be missing sales if you don't have some smaller items priced at $75. Be sure that you don't diminish the quality of your lower-priced items, only the scale; the customers will be drawn to your display by your larger $600 works, and they'll buy the lower-priced items only if the same craftsmanship is in evidence.

7

DISPLAYING YOUR PRODUCT

You've probably heard the story of the fellow who was asked by his neighbor to help train a mule. He immediately picked up a two-by-four and whacked the mule between the eyes, saying, "The first thing you have to do is get his attention." One of my early painting instructors used to say the same thing somewhat differently when giving advice on painting: "Paint it big, and paint it red." This first necessity of getting the viewer's attention is also true in selling art, and the display is your initial means of attracting attention. Judges as well as the public will either pause to look or walk by, depending on their first impressions of your display. An uncluttered, superior display, with your best work prominent, is essential.

There are two important aspects of displaying your work. One is in the presentation of the product, and the other is the display structure itself.

PRESENTING YOUR PRODUCT

The importance of presentation cannot be overstressed. I'm sure you've seen a mediocre work become a winner simply by the way it was presented. A losing $10 print can be transformed into a $25 seller if you make it look important and of special significance by double matting and contemporary framing.

In presenting your product, it is important that the works you are showing be uniform in media. Don't confuse the viewer by displaying drawings, watercolors, prints, and paintings on the same display. If you are entering two categories, try for two spaces with a separate display for each; if that is not feasible, arrange your display so that there is an effective separation of the two media. The judge usually isn't going to take the time to sort your display into the categories you are entering.

There is a belief that the serious artist works within a consistent style, and therefore it is not wise to feature more than one style or technique at a time. Be sure that the works displayed are compatible. Don't show realistic watercolors with abstract oil paintings, which suggests that you are groping for a style and that as an artist you have not found what you want to do—in other words, that you are an amateur.

Similarly, keep your framing consistent. Don't frame some of your works in busy, ornate frames and others in modern metal frames. This, until a few years ago, was my biggest error. I had a hodgepodge of frames, some given to me by friends who had cleaned out their attics and others that I'd purchased at giveaway prices at garage sales. Even when I bought from a wholesaler, I sought the less expensive, assorted ready-mades. Framing to me was more a matter of finding a frame of the right size than one that displayed my work to best advantage. Part of my success in the past few years I attribute to having the courage to get rid of every bastard frame in my possession and start over with uniform frames selected to enhance my product.

Try to make the frame fit the work. Contemporary work demands contemporary frames, while small, jewellike academic works may look better in a wider frame or mat. Make your own decisions. Don't rely on the advice of all frame makers. Since they are in the business of selling frames, some will try to triple-frame everything and push the price to where the frame is more expensive than the work in it.

No matter how well your work is framed, you will occasionally be asked if you would sell the work without the frame, as it doesn't fit into the customer's decor. As my frames are a standard size, and I know that I'll be able to use the frame again, I usually comply. All I will deduct is the cost of the frame, without my labor costs. When I sell a framed picture, I do add labor costs to frame costs in arriving at a price. The labor cost, therefore, is still part of the price of the work, so I only deduct what the frame cost.

I used to put colored mats on my prints, and occasionally I would be asked to change to a mat of a different color. As the sale wasn't usually worth the effort, I generally refused, but I offered to deduct the cost of the mat if they would take it as it was and have it matted to their satisfaction elsewhere. I'm gradually shifting to white mats not only because, as my wife pointed out, white fits all decors, but also because white doesn't fade in the sun on my display, so I have fewer mats to replace.

Although not an essential, if you limit yourself to working in only a few sizes, you can keep a supply of each size on hand, and ordering frames becomes easier. You will be spared running around before a show to order special sizes for oddly shaped pieces. As you have an investment in your frames, try to protect your investment by proper handling. You needn't go as far as one artist who always wears white gloves when touching his work, but do transport your artwork in cardboard boxes with additional cardboard inserted between works. You needn't tape the glass to protect the work in case of breakage, as the cardboard boxes provide ample protection.

Consistency of work also holds true in sculpture. Don't offer your customers eight different techniques in as many materials. Not only will the judge walk by, but so will potential customers if your display looks more like a junk shop than an art gallery.

Craftspeople, such as jewelers and ceramists, who show much more work than other artists, are prone to put out everything they have in stock rather than a selection that will enhance their presentation. You need only display a half-dozen mugs to show the viewer the quality of your craftsmanship, the style of the product, and that sets are available. Showing fewer pieces will not only enhance your display but will provide a conversation-opener. You can mention, to anyone who expresses an interest in the mugs, that you have other sets in different colors. The first step toward a sale is to involve the customer in making a selection from the other sets you pull from the back of your display. If you display eight sets of six mugs all at one time, you will diminish the exclusivity of your product and turn your display into a miniature Woolworth's. A highly successful ceramist I know never displays more than eighteen pieces at any one time.

The same holds true for jewelry. If you have five different sizes of one style of ring, put just one on display. You can always go to your stock to find the proper size. In displaying your work, you should exercise the same care as in taking the slides that gained you entrance into the show.

If you are going after prize money, make it easy on the judge by spotlighting the work you want him or her to consider. As the judge has to make determinations on the work of fifty to a hundred artists in an hour's time, he or she does not have leisure to spend fifteen minutes sorting through your display to find something meritorious. Set the work you hope will win money apart from the rest of your display. If it is a piece of jewelry or ceramics, it should be enclosed in a special case of its own, either within or apart from your total display.

It is best to give your work breathing room, so that each piece displayed is sufficiently isolated for easy viewability. If the show's brochure states that you must display at least four works in your category to be eligible for judging, then show only four works if they are large, and no more than eight if they are small.

Having been in a position to hire art instructors, I know that artists are more likely to put themselves out of the running for a position by showing too much of their work than too little. Twenty well-chosen slides of their best efforts would have been sufficient, whereas eighty slides were not only more difficult to assimilate, but were more likely to include chaff with the wheat. These same criteria also apply to your initial setup for judging. Some artists will load their stands with work once the judge has passed. Be careful, because the purpose of your display is to draw people

in, not to offer them a retrospective of your work since the age of ten. As mentioned earlier, many artists take three times more work to a show than they can sell; don't make the mistake of trying to show it all at one time.

YOUR DISPLAY STRUCTURE

When it comes to your display structure, there are a number of factors to consider. Paramount among these considerations is its attractiveness. Like a good painting, it should carry an impact from twenty feet away as well as from two feet. Your display is in competition as much as your artwork. Its purpose is to bring the viewers in for a look.

A second consideration is your display's weight and portability. Shows held in parklike settings may prevent you from driving to your site, and you will be forced to manhandle your equipment for a block or more. If you are working alone, your display should break down into easy-to-carry segments that won't rupture you or be so cumbersome that you knock down everyone else's display on the way to your site.

Some artists ignore the portable aspect and erect a display on the spot by hauling in tons of two-by-fours and plywood. One artist constructs an entire house on his site, complete with gabled roof, rug on the floor, and easy chairs, to show off his paintings in a homelike setting. He starts at 6:00 A.M. and is still putting on the finishing touches at noon, despite the brochure's admonition that all displays must be erected by 10:00 A.M. There is a potter who creates a virtual Hanging Garden of Babylon in which to display his work and does it in five hours, with pre-drilled holes, bolts, and much profanity. These two artists love manual labor much more than I do; but, as I haven't seen them on the street for the past few years, they have probably given up the struggle or are lying in traction somewhere, recovering from a fall from one of their creations.

As you will have to make several trips to your site with your products, chairs, and cooler, a handcart becomes essential. You can pick one up at a swap meet. I found one for $5. It is aluminum and therefore lightweight. It is sturdy enough to hold all I can load onto it, and the wheels are of sufficient size to go over rough ground or through sand without bogging down. Perhaps its greatest feature is that the base where I stack my work tilts back, so that it will stand upright without dropping work to the pavement. I've seen other handcarts that don't have this feature, and their owners end up buying a lot of glass. There are many different handcarts on the market, so shop around and find the one that best suits your purposes.

A third factor to consider in your display is solidity. Wind is your biggest enemy, and the display must be either heavy enough not to blow over

(a virtual impossibility), or be anchored with stakes and ropes or weights. It is best to be prepared with both, as your space is just as likely to be on a grassy surface as a concrete parking lot. I have seen displays made of 4-x-8-ft (1.2-x-2.4-m) Peg-Board nailed to two-by-fours lifted by the wind and transported two spaces distant, taking everything in their path. Too many ropes and stakes can turn your display into a maze that will either trip or garrot your customers. Surging crowds can jostle your display and tip it if it isn't sturdy enough.

Your display should offer a degree of flexibility in setting it up. Spaces can have a 45-degree slope, man-size potholes, trees, or a depth of only four feet.

Rain is another of the elements that can destroy your work unless you provide protection from it. Intermittent rain is a nuisance because you can spend a lot of time covering and uncovering your work, getting soaked in the process. Come prepared, and don't wait for the rain to hit before you start hunting for a hardware store where you can buy some plastic.

Sun also can be an enemy. Two weekends in the sun can fade your colored mats so badly that they must be replaced, and the sun can dry all of the oil out of your hand-rubbed sculpture or leather products. In glassed work, it can produce sweat which will run down the interior of the frame, ruining both the mat and the artwork.

Every medium has certain display problems that must be solved. Sculptors, whose work may not be hurt by the elements, may have the problem of keeping their work visible. Simply to place your sculpture on stands in your space, without some screening device to block out the other activity around it, will mean that it disappears into its surroundings. Fabric artists. besides contending with the elements, may have to devise a display that keeps the crowd from handling and soiling their work. For jewelers, who usually display their work in flat cases, the problem is to develop a display with a high enough profile to pull customers from across the street. Also, with the high price of gold and silver, security of their work during transportation and while on display becomes a must. Solid displays are necessary for the ceramist. A friend of mine, whose display was engineered for ease of assembly and not for stress, saw his entire setup collapse, turning several months' work into shards.

My display, which I do not consider the apogee of its kind, consists of four panels, each 4 x 7 ft (1.2 x 2.1 m), made of one-by-twos gussetted on the corners by triangular pieces of plywood, and covered with chicken wire and burlap. The panels are light in weight, and I can carry two of them at one time without strain. The chicken wire allows me to hang anywhere on the panel, and the burlap permits some wind to pass through. By

bracing the top and using weights, I've never had it go over even when other displays toppled. I fasten the panels together with bolts passed through metal rings and then tightened down. Before I added the burlap the wind had even less obstruction because it had only chicken wire to go through, but the display resembled something out of "Old McDonald's Farm." The burlap made it visually appealing. I can put up my entire display and hang my work on it in an hour's time, and strike it in 45 minutes. This is one of its great features, for after two days of an art show, all I or the other artists want is to pack up and go home.

Displays wear out eventually, and when they do, you have an opportunity to improve on your last effort in building a replacement. I have plans on the board for a new display which will combine the good features of my most recent one with greater security from the elements and more aesthetic appeal.

Besides caring for your work, make provisions for your own well-being. The sun can burn even on an overcast day, so have a hat or umbrella. Have rain gear handy, as well as warm clothing. A balmy Saturday with 85-degree temperatures can turn into a 45-degree Sunday with a chill factor that would drive a husky for cover. As you will spend a great deal of time sitting, have a comfortable chair. I suggest a high, folding director's chair so that when you are seated, your eye level is the same as your customers'. You can slide out of the chair and into conversation with a customer without sudden motion. There is something about arising from a low-slung chair that customers find disconcerting. Perhaps they feel imminent attack and tend to back off.

I usually take two chairs, both to accommodate an occasional visitor and to provide my customers with a place to sit while they write their checks. Keep your chairs somewhat inaccessible, though, or you will find them occupied for hours on end by noncustomers with tired feet.

If the show you are attending runs into the early evening, a lighting system may be needed. The show's sponsor will usually tell you if outlets are available where you can plug in your spotlights. If they aren't, you can always run lights off a battery or use Coleman camping lanterns.

The fact that 13 percent of artists who sell better than average think that their display is all-important seems to indicate the display as a factor in their success.

TO FRAME OR NOT TO FRAME

Whether to take framed or unframed work to a show can be an important consideration for two-dimensional artists because of the initial costs involved. Over half of the artists display only framed works, and 16 percent

display only matted works; the remainder display both and notice no difference in sales between the two.

Your decision may be governed by a consideration of the type of customers you are seeking. When I first hit the street with prints, I took out only matted works. I discovered that a friend, whose gross sales were twice as great as mine, netted no more than I did. He aimed for the big sale with rather large prints priced at $200-plus but framed all of his work somewhat too expensively, although he did it himself. My unframed prints sold from $6 to $30, as I aimed at the average buyer who usually carries that much walk-around money. Granted, I had to sell more than he did, but I was spared the cost and time-consuming chores of framing.

Since that time, I have started framing at least one print in each of the images I'm showing, keeping an unframed print in my portfolio so that I'm prepared for either request. Although I make no money by framing, except that I charge for my time, some customers do want to be spared the effort of either framing the work themselves or taking it to a framer. If my customers are at all price-conscious they realize that they can't beat my framing price; but I don't push one way over the other. The reason I started to frame was to enhance my presentation and give my display uniformity. Many customers are drawn to a display for this reason, although they may eventually purchase an unframed work from the portfolio. I sell greater numbers of matted prints, but dollar sales are greater for framed pieces because people who buy higher-priced prints prefer them framed and ready for hanging.

Framing costs are high and going higher. This is another reason to consider taking fewer works to a show. It is less expensive to frame eight pieces than twenty-four, and the fewer you haul the less chance there is of damaging your frames.

GOING WITH THE PROFESSIONAL FRAMER

As 64 percent of the artists indicated that they do all their own preparation of frames, sculptural bases, and other presentation devices, you may be sure that costs for professional services are so high that the average artist cannot sell if he must add this cost to the price of his work. About one quarter of the artists have some work, such as building frames, done by professionals, but will do part of the work themselves, such as the assembly. Price is always a consideration for the buyer, and your materials and labor in making your own frames amounts to about a third of the cost of a professional job. It's dull, tedious, time-consuming work, but it does give you control over the craftsmanship.

Only 8 percent of the average artists use professionals entirely in pres-

entation preparation, compared to 14 percent of the more successful artists. Perhaps this suggests that as your sales climb, it may be to your advantage to turn over more tasks such as framing to others. If you charge only $5 an hour for time spent in non-art tasks, but estimate $20 an hour for creative and promotional time, it is obvious that doing your own framing doesn't pay. I'm sure that if you look around you could find someone with an eye to a dollar and craftsmanship enough to relieve you of this time-consuming work. I might add, I look forward to the time when higher sales will allow me to do just that.

8

A GALLERY OF
DISPLAY IDEAS

Although some commercial display equipment is now available to street artists, the vast majority still prefer to design and build their own displays. Over a period of time, most artists develop a display which not only shows their work to best advantage, but also meets a number of the other important criteria discussed in the preceding chapter—sturdiness, portability, ease of assembly, visibility, protection from the elements, and so on. The displays pictured here illustrate a variety of ways in which individual artists have not only met these needs but expressed their personal preferences. Hopefully, the setups shown in these photographs will suggest ideas that you can adapt in designing your own display.

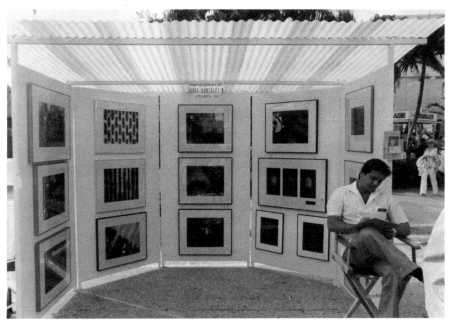

The five canvas-covered panels of Jorge Gonzalez's display are arranged for maximum visibility. The corrugated fiberglass roof permits soft light for viewing while minimizing reflections that would be caused by direct sunlight.

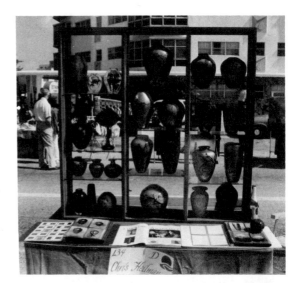

This glass-shelved vertical display allows light to dance around Chris Heilman's blown glass. Placed high off the ground for easy viewing, it calls attention to the work being shown.

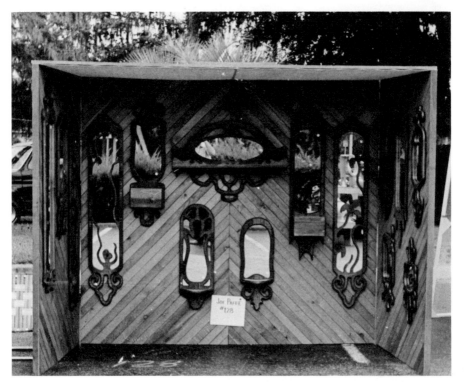

A canvas roof protects Joe Paffe's hand-carved mirrors from the sun as well as sudden showers. The diagonal pattern of the lightly stained wooden background provides a pleasing contrast for his dark, organically shaped mirrors.

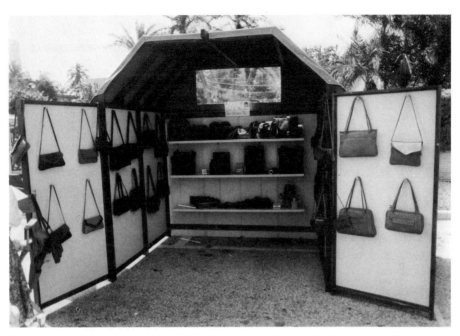

Framed Masonite panels painted white and protected by a raised canvas roof form an attractive background for Leah Donahue's hand-crafted leather purses. The two forward panels can be closed in case of rain.

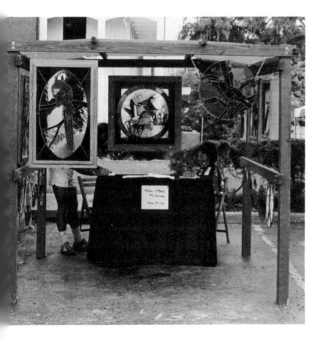

An open-sided shelter allows customers to view Mike and Mary McIntyre's stained glass in an ideal setting with proper back lighting. The canvas roof darkens the enclosure, adding to the effectiveness of the display.

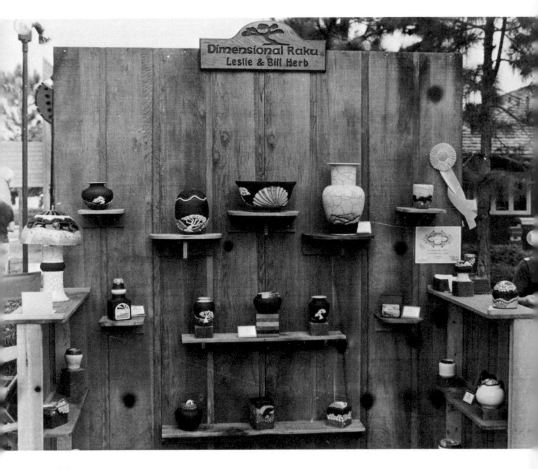

Above
Neutral board-and-batten paneling enhances Leslie and Bill Herb's high-contrast raku pottery. Because each pot is given its own space, viewers can concentrate on individual pieces. When work is sold, it is replaced from a supply hidden behind the display.

Opposite page, top
Stepped shelves not only form an ideal stand for Susan Kurtz's ceramics, but also hide a storage area for the cartons in which she transports her work. The vertical lattice background gives the display high visibility and cuts out background distractions, allowing customers to focus on her pottery.

Opposite page, bottom
Blown glass, which needs no protection from the elements, is exhibited in the open by John Byron. His multi-level stand with a diagonally slatted white background serves a double purpose: it blocks out distractions and also gives his pieces high visibility, thereby solving two problems that frequently occur when items are displayed horizontally.

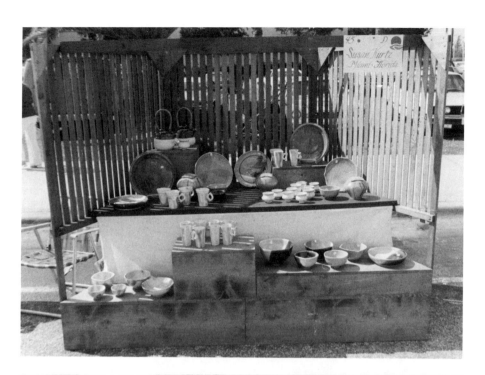

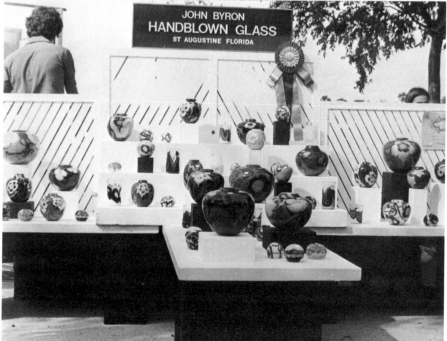

Above
P.V.C. pipes covered with strips of webbing make a lightweight, easy-to-transport structure. The large canvas roof awning, raised at the center for drainage, also provides ample shade.

Right
Eight hollow-core doors, hinged in sets of two, allow customers to walk in and around David Ray Good-speed's uncluttered display. The doors are rigidly held in position by interlocking two-by-four roof braces.

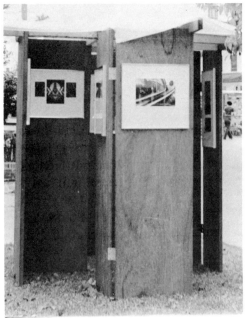

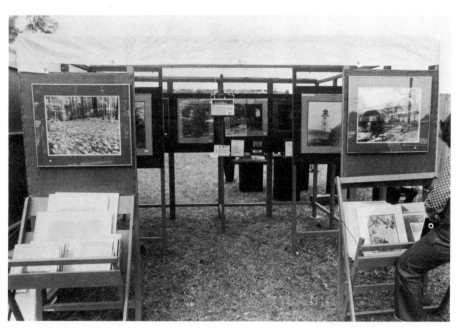

R. S. Spann's photographs are hung at eye level on burlap-covered hardware cloth stretched over two-by-two frames and placed in two facing E-shaped arrangements. A flexible, canvaslike roof of woven fiberglass allows light to enter the display area but also affords protection from sun and rain. Note the collapsible browse racks.

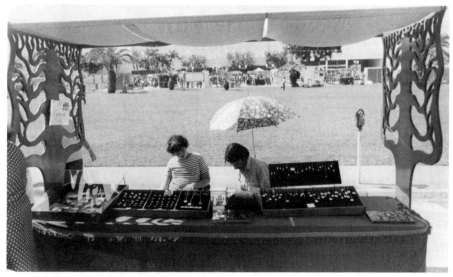

A canvas awning stretched between filigree supports helps to eliminate glare from William Rogers' glass-topped jewelry cases. It also attracts patrons to his display, which would be less noticeable without it.

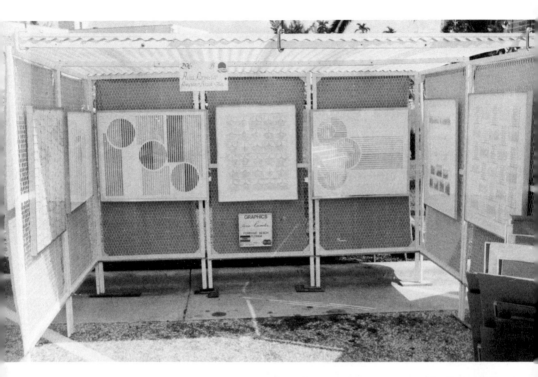

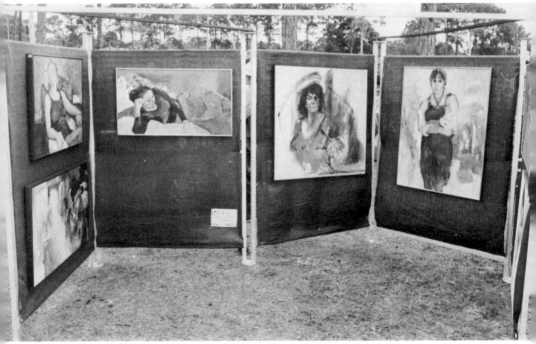

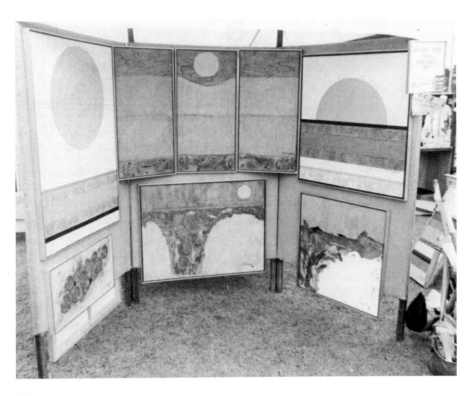

Above
Five panels framed by two-by-two's, covered with burlap, and placed with their ends angled give Pat McNerney a rigid structure on which to hang his large, colorful abstract paintings. The display is viewable from all sides, providing double the amount of hanging space possible with the usual three-walled, open-ended construction. A canvas roof provides shade and protection from rain. Legs raise the panels off the ground so that moisture won't stain or rot the burlap.

Opposite page, top
Canvas-backed chicken wire stretched over a gusseted one-by-two frame forms the basis for Aina Parmelee's lightweight, portable setup. Each piece of artwork is allowed its own display space, and additional work is shown in the portfolio. Note the wooden shims used to level the display.

Opposite page, bottom
Commercial display racks constructed of lightweight aluminum are easy to transport and set up, but the open mesh offers a confusing background for artwork. Jeanne Schubert's solution was to cover her racks with a dark cloth, which is removable when it's time to knock down and transport the display.

9

PRICING YOUR WORK

Occasionally visitors at the school where I teach will walk through the studios, spy student work they admire, and make an offer to purchase. The student then asks me, "What should I charge for this painting?" There is no easy answer to this question, but in pricing your work you should consider three factors: supply and demand, what the traffic will bear, and costs plus labor.

SUPPLY AND DEMAND

If you are one of the fortunate artists for whom demand exceeds supply, you can adjust your price upward until you strike a balance between the two. The Everglades painter referred to earlier found himself in just this enviable position when he was selling out at every show. Some shows he committed himself to attend ran on consecutive weekends, and he was unable to produce enough work to fill his racks. He was showing up with as few as four or five paintings, and was forced to cancel some commitments because of dwindling stock. Making a bold move, he raised his asking price to $300 for a type of painting that he had previously sold for $150. If the players on a football team try for a first down on their fourth down and make it, they are hailed as courageous heroes; if they fail, they are considered foolish. My friend came out a hero, as his total sales stayed constant and he was working only half as hard for the same amount of money. He exhibited more courage than I possess. My preference would have been to raise prices in $25 or $50 increments. To jump too far too fast can cause problems. Another artist, not a street artist, was induced to double his price by the gallery that handled his work. His sales dropped significantly. After a few long-standing patrons bought at his new prices, he couldn't risk lowering his new figures without raising their ire and losing them as customers. He put in a few traumatic years, and finally solved his problem by changing to a different medium.

I had a similar problem on a minor scale when I started taking prints to art fairs. I priced my small serigraphs at $6 and sold at that price. Tiring of carrying a pocketful of one-dollar bills with which to make change, I dropped the price to $5. Customers who had purchased at the $6 figure

reacted unfavorably to the price drop and called it to my attention. Not only did I upset customers, but my laziness about making change was costing me as much as $50 at some shows. Then I reversed myself, raising the price to $7. During all this price-switching, the volume of sales remained constant. It seems that a dollar one way or the other on such a low-priced item is of no great concern to the customer.

PRICING AT WHAT THE TRAFFIC WILL BEAR

Pricing work at a figure you feel someone is willing to pay is the method used by most artists who do not make their entire livelihood from art fairs. They are in shows to enjoy themselves and to pick up some extra money for luxuries and art supplies. They arrive at the asking price for their work by observing what other artists charge for a comparable product, or they will switch prices around until they arrive at a figure that seems fair and, they hope, inviting. Some avoid exact accounting because it might show that they aren't doing as well as they imagined they were, and they prefer blissful ignorance. For these artists, time is not too great a consideration, and they are willing to put a great deal of work into a product that may only realize a few dollars an hour. There is nothing wrong with this approach if it happens to suit you, but by assuming this posture you may be letting dollars slip by, and thus remain only average in sales.

For the professional artist who must demand fair value for his work in order to survive, the semiprofessional with lower prices is a problem. It's a free country, and prices cannot be dictated, so the only solution for any artist is to produce a product so superior that it commands a higher asking price.

THE COST-PLUS-LABOR METHOD OF PRICING

This pricing method requires an accounting of both time and materials to arrive at a base figure for your work. To make it operate, you must first decide what your time is worth. If you are a beginning artist and have not invested substantial sums of money and time in your education, you should expect a smaller return than if you had incurred these expenses. Be realistic about the figure you choose. I use two different figures, depending upon the type of work in which I'm engaged. If I'm painting, designing prints, working on the etching plate, or doing something else that calls upon my artistic skills, I label it creative time and assess it at $20 per hour. I use this $20 figure because that is what I am paid for teaching private classes, comparable because that also calls for the use of my artistic skills. If I'm cutting mats, framing, running around picking up supplies, or doing only semiskilled work, I value my time at $5 an hour. I figure I could hire

someone to do these things at that figure and, if pressed for time, will indeed pay that amount to an assistant.

Accurate records must also be kept of what you paid for materials, as well as their current value. Always figure the costs of materials on the basis of replacement cost. If you laid in a supply of watercolor paper five years ago at a cost of $2 a sheet and the price has since doubled to $4 a sheet, charge the latter figure. Keep a work sheet, by project, so that you will know the amount of time spent on each endeavor. Many media will fit well into specific time commitments. Prints, paintings, and weaving are much easier to put in terms of work hours than, say, ceramics, where you may spend a week doing nothing but throwing numerous pieces, a few days in trimming and glazing them, and another few in firing them. Consequently, it may be impossible to keep track of the time spent on each individual piece; but it's possible to lump time and materials on sixty works and then ascribe time to individual pieces according to their scale or whatever criteria you use. An example of a work sheet is on page 103.

Experience may tell you that the time and money you spent attending art shows the previous year equalled one-third of your sales. (This will vary with the individual, so I've selected a reasonable figure as an example.) These expenses were for promotion and selling, and should be added to your labor time and materials costs.

Labor and materials cost	$6.25
Promotional cost (⅓ of total cost)	2.08
The least I can sell a single print for is:	$8.33

You can't adjust the price downward on individual sales, or you'll be losing money, but it is possible to raise this final figure if the quality of the print and its market potential so indicate. You could ask $15.00 for the print; it would still be competitive at that figure and would allow you a comfortable profit. This price would also allow you to wholesale a quantity of prints at one-third off and still make money. You could also sell the entire edition at one time for half off, and make labor and materials costs.

Everyone is aware of the pricing technique of marking a product at $19.98 rather than $20. The psychology behind it is that the customer sees the $19 as being less than $20. If you mark the product at $20, the customer will envision a $20 bill, which is one-fifth of $100, and he may decide that he doesn't want to go that high. Does this gimmick work with art? Most artists deal in round figures, so they obviously haven't given it much thought. I have noticed that when I raised the price of a print from $18 to $20, sales dropped off.

I have well-meaning friends who berate me for my low prices. They ar-

WORK SHEET

Project African Traveler, silkscreen 10×15 in.
(25×38 cm) 3-color edition of 25

LABOR COSTS

Date	Activity	Time	Labor Costs
Jan. 3.	Stopping-out for first run	1 hr @ $20 per hr.	$20
	Pulling first run	2 hr @ $5	10
	Stopping-out for second run	1 hr @ $20	20
	Pulling second run	2 hr @ $5	10
	Stopping-out for third run	1 hr @ $20	20
Jan. 4.	Pulling third run	2 hr @ $5	10
	Cutting mats, backing board and acetating prints	4 hr @ $5	20
		Labor cost of 25 prints	$110

$110 labor cost divided by 25 usable prints = $4.40 labor cost per print

MATERIALS COSTS

30 half-sheets of print paper @ $1.25 per sheet (Although the edition was only 25, extras were printed in case some were off register or smeared in the printing)	$18.75
7½ sheets of mat board @ $2.50 a sheet	$18.75
25 ft. (7.6 m) of acetate @ $.15 a ft (0.3m)	3.75
Ink (estimated cost)	5.00
Materials costs	$46.25

$46.25 materials cost divided by 25 usable prints = $1.85 materials cost per print

Labor cost per print	$4.40
Materials cost per print	1.85
Total cost per print	$6.25

gue that people will take my paintings more seriously if I offer them at $1,000 rather than $500. Customers, they maintain, equate price with quality. I am not averse to asking $1,000 for my paintings if they will sell for that figure, but art-fair customers only rarely pay gallery prices. I would rather sell at a fair price than ask for inflated prices and starve.

Keep your prices current. I know artists who haven't changed their prices in the past five years. They complain about the high cost of materials, increased entry fees, and mounting gas prices, but are reluctant to increase their asking prices commensurately for fear sales will decline. The end of the show season is a good time to go over your records and plan courses of action for the next season. If you find that your sales remained the same as the previous year, but that increased costs cut into your net profit, it is time to adjust your prices upward. If you use the time-plus-cost method of pricing your work, you won't need to adjust because your cost will already have been considered.

THE WORK ETHIC AND YOUR PRICE

Americans like to think they work hard for their money, whether it is true or not. Although they are disposed to buy novelty items if the price is low, in major purchases they want to see evidence that you spent enough time on the work you are selling to justify your asking price. They expect a day's work for a day's pay.

Your goal should be to produce a product that gives this evidence of time involvement. If you can turn out a painting in four hours that looks as if it took four days, you can make money. However, if you take four weeks doing this same painting, you are in deep trouble.

There are draftsmen and painters who spend as much as 60 hours on a single effort. They are, consequently, forced to charge less for their time to keep their product within the price range of the average buyer, or else go after the prize money and be content with few or no sales. Is there a way out of this dilemma? Some artists have taken the easy way out by having their work reproduced by the offset printing process. Printmakers like myself, who hand pull our own prints, decry this solution; major shows share our attitude and won't allow offset prints to be exhibited. I can sympathize with the artists forced to this expedient, but would prefer a different solution.

Although your product may be one of a kind, there are phases of your operation that may benefit by mass-production techniques. With a paint roller, I can put a gesso surface on six canvases in less time than it takes to do one with a brush. As my studio isn't large enough to locate certain activities in specific areas, I must clear off my work table whenever I switch

an activity. I find it a time-saver to set aside at least half a day for each activity. Consequently, I never frame a single work, but instead I wait until I have thirty or so pieces ready and frame them all at once. You can save time not only on physical tasks but also on many creative tasks by using an ingenious approach. Working on five paintings at once will not only force you into a stylistic consistency, but once having arrived at solutions to painting problems, you can use them, where applicable, in more than a single painting.

I also found I could do a hard-edge painting without the time-consuming method of taping off areas. I use a tightly woven canvas with very little tooth, place the unstretched canvas on a hard surface, stop out areas with paper stencils, and paint with a roller, using a very light touch and very little paint. Time saved on a single painting can amount to three days.

When I am doing more than one painting at a time with the same colors, I save in addition the time needed for mixing paint and assembling materials, and also in clean-up time.

When I first started doing multicolor etchings, I was using only a single plate and spending four hours on each printing. By purchasing a second plate for $25 and cutting out separate areas that could be inked independently and dropped into a template, or master form, for printing, I cut my printing time to under one hour. The time saved on an edition of thirty prints was 90 hours, or $1,800 in creative time. The prints still sold for $200, and my profit increased by over 150 percent.

Changing materials can also save time and increase profits. Acrylics dry in minutes, whereas oils take weeks. If you work with glazing techniques, a switch to acrylics could save countless hours. It is also possible to start a painting in acrylics and, once the compositional force is established, switch to oils.

If you are out to make money but can't bring your product in at a profit, then consider changing products. It is easier to sell editioned items, such as cast sculpture and prints, because of their lower price, than one-of-a-kind products, unless you have organized your techniques and imagery so that you can keep your production time to a minimum. All successful street artists have developed a system that allows them to turn out a product with an eye to the clock. They have been forced to set parameters on experimenting, to make their production time pay off.

PRICE AND SCALE

The scale of your work and the price you are asking for it are only roughly relative. You cannot apply a mathematical formula to scale and price. You may get $100 for a 2-x-2-ft (0.6-m-square) painting. A painting that is

five times as large, or 4 x 5 ft (1.2 x 1.5 m), will not necessarily bring $500. The scale of this larger painting may even be detrimental to its sale, as most people can't adjust to having art dominate their living rooms. I know a young couple who sell their ⅜-in.-square (.95-cm-square) cloisonné enamels for $250 to $350; I know another enamelist who would be more than pleased to receive $200 for his 12-x-18-in. (30-x-46-cm) works.

Quality of product and desirability, rather than scale, determine price. Is there an optimum size for a painting, sculpture, piece of jewelry, ceramic pitcher, or whatever product you are selling? Common sense would say that a pitcher too awkward or heavy to lift when filled would be in little demand, as would a pendant heavy enough to cause bruises. Take advantage of someone else's marketing research; walk through furniture showrooms and note the scale of the paintings, prints, and sculpture they have on display. Judges, however, react favorably to scale, and work too large to be marketable can win prizes. I know a printmaker whose small prints, double the size of postage stamps, are far superior to mine in technique; however, recently my large 30-x-36-in. (76-x-91-cm) framed prints won over his in three of the four shows in which we competed.

BARGAINING

Bargaining is not a popular way for the art-fair artist to do business. Less than 10 percent of artists say they enjoy the procedure and over one-third flatly refuse to bargain in any circumstances. However, 28 percent will bargain on a volume purchase, and another 28 percent will bargain if they see they are losing a sale. If you feel your work is priced honestly, it is a tough decision to take less than it is worth. The "mark it up so it can be marked down" theory prevalent in much retailing is not subscribed to by artists. Street artists in particular work on such a narrow margin of profit that too much bargaining could put them out of business. If they bargain at all, it is apt to be with someone who expresses a sincere desire for their work but obviously doesn't have the total purchase price. They are less likely to give a break to someone wearing a mink coat and lorgnette. If you are forced into bargaining, it is obviously easier to shave the price on a $300 item than on a $3 item because most people think in terms of dollars—and $1 off a $3 item is one-third, while $25 off a $300 work is only one-twelfth. Artists almost never suggest bargaining but wait for the customer to mention it. If I find customers torn between two or three of my works, I will suggest an attractive price for the purchase of more than one. As these discussions of choice are usually between a husband and wife, where each has a favorite, the offer is rarely refused. I figure the sale of the second or third item a bonus because in all probability I wouldn't have

made the additional sale had I not made the offer. Sometimes a show gets a reputation as a bargain-hunter's paradise. The merits of attending such shows must be weighed on an individual basis. If it is a high-sales show, bargaining may have to be accepted as a matter of course. If the show produces low sales, and you must bargain just to break even, you might be better off dropping that show. I have done just that.

THE RATIO OF PRODUCTION TIME TO MARKETING TIME

The average artist attends eight shows per year. Those in the upper 3 percent of sales averaged only slightly more, attending about ten shows annually. The figures suggest that the number of shows attended was of less importance than the quality of the shows.

The costs involved in attending a show, besides the entry fee and transportation, are fairly constant. Ideally, you are better off repeating only the shows that have been big sellers for you, and dropping the marginal ones. I know artists who have left secure jobs to devote their entire energy to producing and marketing art, living entirely off the proceeds of sales at sidewalk shows. They usually start off by trying to fill every weekend with a show, and husband-and-wife teams will often split up to cover two shows on the same weekend. After a year or so of this feverish activity, they find that they are wearing themselves out by attending too many shows which are only marginal in sales, and they will cut back drastically in the shows they enter, concentrating only on the high-profit shows. The physical and emotional stress in showing on the street is greater than an inexperienced person would imagine. If you devote too many hours to selling your work, you don't have time to maintain quality; and if quality suffers, so will sales. Some artists who work the street only part time because of other bread-winning jobs may find that their production will support only a few outings per year. Every artist will have to find his or her own ratio of production to marketing time.

10

KEEPING RECORDS

There are a number of reasons for keeping records, and all of them are good. You may look on this activity as a tedious chore that deprives you of creative time, but the opposite is true. With a proper system, you will not only know where you stand financially at all times, but at income-tax time you can compile the necessary information in a few hours instead of spending days seeking lost receipts, going through check stubs, reviewing credit-card receipts, checking past phone bills, and worrying over what you may have forgotten that could give you a tax break.

When you are laying out your itinerary for the year, do you remember to the dime, the dollar, or even the hundred dollars, what you took in sales at any particular show the past year? You should, as it could influence your decision to repeat a show or seek a greener pasture.

Have you ever been preparing to send your entry blanks to a show, and forgotten which slides you sent last year? When you go to a show, have you forgotten what slides you sent for jurying, or possibly even what category you entered? If you enter twenty or so shows a year, this could happen.

Do you ponder the name of the lady who expressed a sincere interest in one of your works, and inquired if you were attending another nearby show where she could bring her husband to see your work? Who was she, and which show was it? (It would be dreadful to attend that show and not have the piece of work she was interested in.) Or, what was the name of the patron who spent $400 on your work and indicated a return next year to check out your new offerings? Remembering that name could be the first step to a repeat sale. None of these problems need occur if you take the care to organize yourself and develop a system where the answers are always available. I'm not suggesting that it is necessary to get a double-entry ledger and an accountant's pencil, or to burden yourself with monthly profit-and-loss statements. I'm not averse to this method of accounting, should it be within your capabilities, but what you need is some system you understand, that will contain the data necessary to conduct your business in a non-chaotic manner. You may develop your own system, borrow mine, or modify mine to accommodate your own product or approach.

In the previous chapter I suggested a system for figuring the costs in time and materials necessary for setting an equitable price on your product. You will also need a form for keeping track of each show you enter. This form should contain the name and location of the show, as well as the dates of the show. As many shows repeat dates, this information will allow you to plan next year's general itinerary. Fees should be noted, as they are deductible expenses; also, the fee charged will help you decide if the show was profitable enough to repeat.

If you figure actual mileage at the standard deductible rate, note your mileage before you leave home and when you pull into your driveway on your return. You can get mileage from a road map, but it won't account for the miles you put on driving around to find the show site, your trips back and forth to your motel and restaurants, and other driving you find necessary while at the show. At the presently allowable 17¢ a mile, the $17 you spent on 100 miles of incidental traveling in the course of a show might as well come back to you instead of going to Uncle Sam.

Lodging expenses should be recorded, and receipts collected. If your room was comfortable and close to the show, you may want to return; so be sure you record the name, address, and phone number of the motel, and what room number you might want another year. Your major motel receipts will have addresses and phone numbers on them, but the mom-and-pop motels may give a receipt with no information except cost. If the motel you stay at is uncomfortable or too expensive, ask fellow artists where they found a better deal, or cruise the motel strip recording names and addresses for the next year. Older, proprietor-owned motels in the downtown sections of towns are cheaper than the newer chains erected on beltways or major thoroughfares.

Meals are often difficult to get receipts for, so you may want to use your standard deductions; but do record what meals you ate and how many. If you entertain a wholesale buyer, or even a fellow artist whose brain you are picking, it is a legitimate business deduction; get a receipt and record the date, the restaurant, the name of the person you entertained, and the nature of your business. Try to use credit cards whenever possible to pay for gas, lodging, or meals, as it gives you a double check against your figures and an irrefutable receipt. If you pay tolls, ask for a receipt. A toll may only cost a couple of dollars, but a couple of bucks multiplied by 20 shows will come to $40.

Your form should also have space for incidental expenses. It's surprising how much you can spend under the pressures of a show, and how easy to just forget what you purchased. When the clerk hands you a receipt, note immediately the name of the store, the date, and the nature of the

purchase so that you can record the information that evening.

Your show form should have a place to record each sale, listing the object, the price you received for it, and the sales tax collected. If you have recorded the title of the work, you won't spend hours futilely searching through your storage room looking for something you sold two years ago. When I return from a show, I don't have to spend hours unloading my truck in order to inventory my stock. All I have to do is check my list of prints sold, pull out new copies of those prints, frame them up, and I'm ready for the next show. By recording the price I received for each work, I can make an immediate assessment of how well I sold; and by deducting expenses, I have a quick, accurate picture of how well I am doing.

Attending shows is a time investment, and you should place a dollar value on the time you actually spend at a show as well as your travel time. This is important, because you can't figure real costs unless you know the cost of marketing your art. Without that figure, you will have trouble determining what to charge for your product. You may use any figure you choose, but I have settled on a rate of $5.00 per hour for noncreative travel and show time. I count just the eight hours of the day when I'm actually doing business.

There should be a place on your form to note the slides you sent for viewing, so you don't repeat with the same slides next year. Also note your space number so you can ask for it again if it was a good one, or record the numbers of better spaces you may want to ask for next time.

Space should be provided for notations on the show that might be of future help. If Mrs. Smith was high on your work and purchased a piece for $300, and you feel she is a likely patron, record her name and address (taken from her check), and your reason for making the notation. You may want to drop her a card before next year's show, letting her know you'll be there.

The day after you return from a show, spend a few moments to finish filling out your show sheet while everything is fresh in your memory, and place it in a notebook along with your brochure from the show, the map of the display locations, and any other pertinent information. You will thus have at your fingertips all of the information you need for tax purposes, as well as useful reminders on every show attended. A sample show sheet appears on page 111.

Besides keeping tab on the costs per unit merchandised and your costs per show, it is also important that you keep an accurate record of related expenditures that you make between shows. These can include rent you pay yourself for space used, telephone, salaries, and materials. Major purchases of materials you will naturally record, but don't neglect those easy-

SHOW SHEET

NAME OF SHOW _____ SPACE # _____

LOCATION _____

DATES _____

FEES _____

SLIDES SENT _____

MILEAGE _____

SALES AND-TRAVEL TIME _____

LODGING COSTS AND LOCATION _____

MEALS _____

MISCELLANEOUS EXPENSES _____

SALES

ITEM _____ PRICE SALES TAX

NOTES

to-forget minor purchases as well: paper towels, mineral spirits, hanging wire, and any other materials you buy in conjunction with operating your art business are all deductible. Be sure to record the nature of any such purchase on the receipt and put it in a file. Minor purchases can total hundreds of dollars a year.

Many years ago, when I was running a restaurant, I had a cook who also doubled as my buyer. She would spend hours haggling with the merchants who supplied us, to bring the price per pound down just a few cents. When I inquired why she put forth all that effort, she replied, "I've been in this game for thirty years, and have found it is easier to talk for it than work for it." Always shop around for the best prices. We are creatures of habit and tend to return to the same supplier year after year because we know him, he accepts our personal checks, he is handy, or for similar reasons. He may even have been the cheapest at one time, and if he still is, there is no reason to change. However, keep shopping around because you may run into sales or better deals elsewhere. Prices can vary considerably, and you can make money by not spending it. As an example: a local framer sells a 30-x-36-in. (76-x-91-cm) metal frame for $14.60; a wholesaler twenty miles distant sells the same frame for $8.40; and still a third framer some fifty miles away has his priced at $5.94. These are actual figures. If I were to order 100 frames from the most distant wholesaler, paying the 10 percent delivery charge, I'd save $187 over the second merchant and a whopping $807 over the local framer. If art is your only business, you may want to secure a tax number, which allows you to buy wholesale. If you don't have a tax number, most wholesalers will still sell to you if your order is sizeable and if you have a letterhead showing you are a middleman who intends to resell. If you do have a tax number, some states will ask for a year-end listing of your raw materials, and levy a tax on them. Check before you pick up a tax number, because you can do business without one.

Two hours on the telephone can save a day of running around comparison shopping or ordering supplies. Keep a pad near your phone so that you can record the long-distance calls made, and when the bill comes you will know exactly which calls were for business purposes. You can also deduct a percentage of your bill for business-related local calls. Being neither a lawyer nor a tax consultant, I am not in a position to give definitive advice in these matters, but you should check with your accountant or tax preparer about these and other potential savings. If you use part of your home exclusively for your artwork, you can deduct the cost of renting that space as well as a portion of your utility bills. You have to be able to prove, however, that the area for which you claim a deduction is not used for any other purpose. If you paint on your kitchen table, forget it. If your spouse and children are involved in your production, there are tax advantages to paying them a salary, as it cuts down on your net profits. Again, check with your tax expert, as you may be paying the government as much as 10 percent of your net profit which could be kept in the family.

11

KEYS TO SUCCESSFUL SALES

This is the chapter you have been curious about, and probably the reason you bought the book. You may also have been dreading this chapter, because I'm going to explain where the average artist is going wrong, and suggest that you change if you want to increase sales.

Of the artists surveyed, 85 percent go with the soft sell because they feel their work sells itself; some will give help to the customer, but only if asked. In singling out the factors that contribute most to their success, 87 percent put their product first, 10 percent attribute success to their display and presentation, and only 3 percent credit salesmanship, which comes in a distant third. The general attitude was summed up by one of the artists' comments: "If I were to push sales, I suspect I could double my income, but I don't intend to acquire that trait, as I prefer to like myself." I hope he likes himself poor, because he is likely to remain that way unless he gives selling the attention it deserves.

I am amazed that artists will spend years and thousands of dollars in training, months producing products for a show, money and time preparing a proper presentation and paying an entry fee to attend a show many miles away—and once there, suddenly withdraw into a shell.

"THE BUSINESS OF AMERICA IS BUSINESS"

Calvin Coolidge is credited with that remark, and there is no denying its validity. I doubt if a day goes by when the average American does not engage in business of some sort. It may be as simple as buying a loaf of bread, but it calls for a meeting between buyer and seller. It is such a simple thing that most of us don't give it much thought. That is, we artists don't think about it until we are placed in the position of the seller, and then the title "salesman" takes on horrifying implications. We suddenly envision the hustler in a checkered suit with a pencil-thin mustache trying to sell a beat-up used car for four times its value, or the insurance salesman who last tried to frighten us into buying an insurance policy with a premium guaranteed to keep us in eternal poverty. We remember these types and declare that we "don't want to be like that." What we don't remember are the other 99 percent of the salesmen we've encountered who didn't hustle us, but were, in all probability, most successful in getting us

to buy what they were selling. They did this by presenting their product intelligently, by pointing up their product's superiority to its competition, by flattery, and by an air of trustworthiness and confidentiality; they were so smooth in their presentation that most of us not only bought, but were convinced that we had made the proper purchase.

Most of us have spent our time becoming artists, and look on selling as some mysterious gift given only to a few. We blithely ignore the books on selling and the courses or symposiums offered because we have bought, at least in part, what I call the van Gogh syndrome. We believe, that is, that the artist must suffer and endure for art, and that he or she always has been and always will be a second-class citizen simply by having chosen art as a profession. Artists feel that they are the twentieth-century equivalent of the Japanese samurai who disdained anything commercial as being beneath the dignity of their profession. This posture is so far from the truth that it hardly bears comment. We are living in the twentieth century, when concepts of earlier times are no longer valid if ever they were, and it's sheer idiocy to apply them to the present. No one outside your immediate family cares if you succeed or fail. There is no place set aside for masochists, for those who believe they are chosen to carry the torch of unadulterated creativity. Satisfaction and rewards go to those who recognize the art scene for what it is, and not as many envision it. Success in art, as in any other endeavor in America today, is based on the dollar sign. I'm not deprecating those who care to pursue dreams, but I doubt if a bookie would give odds on their success. If you want to make it in art you must be a promoter, a public relations person, and a seller of your wares, or else be willing to pay others to further your interests.

If you are your own agent, as you are when you participate in art fairs, you must be willing to wear the salesperson's hat and be determined to acquire the skills necessary to ensure success. In all of the books I've read on sales, not one author has even suggested that sales ability was an inherited or inborn characteristic. All authors admit to a series of failures in sales before they hit on a winning formula. Anyone, regardless of background, can become a salesperson, and sales ability is one of the three major factors that make for success in art.

WHAT IS A HUSTLE?

Think back to the last car or van you purchased. You had your needs in mind, and you shopped around until you found something that filled these needs at a price you considered fair. During your shopping, you were probably subjected to a great deal of pressure and conversation from salespeople, which actually had very little effect on your final decision.

You found what you wanted, and although you may have been taken aback at the price you had to pay, pay you did because you felt it was the best deal you could make. Do you feel you were hustled? If you started out to buy a Volkswagen and ended up with a Cadillac, you were hustled; but if you ended up with what you wanted, you weren't.

Pressure selling only works on the ignorant, and the average art purchaser isn't going to give in to pressure or scare tactics. Don't, however, confuse hustling with honest statements that might lead to a sale. If someone is considering the purchase of one of your prints, and it so happens that it is the last of the edition, there is nothing wrong with apprising the customer of that fact. To mention that you sold four of the prints in your last four outings is also permissible, and will let him or her know it's a demand item. If you're particularly high on one of your paintings, there is nothing immodest about mentioning it. If someone shows an interest in a painting that won a prize at a past show, tell the customer about it. Everyone likes success stories, so share your successes with your customers.

There is competition not only among the artists showing, but also among the customers. To mention that someone else is interested in a certain art object will often hasten a positive decision. I have had customers ask me to hold a work they intended to purchase, so they could travel the show unencumbered. I usually ask for full or part payment to remove a work from my display. Often, someone else discovers that work in its hiding place behind my stand and expresses an interest in it. People seem to want a thing they cannot have.

DO'S AND DON'TS THAT INCREASE SALES

How you conduct yourself when selling your work is all-important because your attitude projects a certain image of you to your customers. A dynamite product will remain on your display if your personality and attitude turn the customers off. At the expense of sounding like a concerned parent, here are some things you should consider if you are serious about increasing sales.

First of all, when you are tending your display, don't read, smoke, drink booze, sleep, carry on idle conversations with friends or relatives, wander away from your display, or deport yourself in any way that suggests you don't give a damn. Some artists go so far as to not even sit down while at their display, but instead they busy themselves cleaning glass, rearranging their display, or occupying themselves in other ways that suggest they are concerned about their product. This gives the customer the feeling that the artist's work would be a prestigious acquisition. I mentioned earlier how the mere act of rising from a chair can frighten customers away. If

you aren't seated, this can't happen. Your first obligation is to the customer, not to your personal comforts and indulgences.

One of the best street salesmen I know will stop his conversation with me in mid-sentence the second a customer pauses in front of his display, and he will immediately give the customer his full attention. People associate indifference with a supercilious attitude. No one wants to be ignored or made in any way to feel inferior, and you do just that if you are not totally dedicated to fulfilling the customer's need for attention. Think back on your experiences and recall the sales you have lost because you allowed a conversation with a friend to drag on one sentence too long, as a consequence of which a customer walked off. How many times have you returned from a leisurely stroll around the show to learn from your neighbor that someone was interested in a specific piece of your work but despaired of waiting, and left with the easy exit line: "I'll be back." They seldom return. No matter how agreeable or pleasant your neighbor may be, he is there to sell his work and not yours. He may be kind enough to collect the money for an item of yours if someone finds him and forces him to take it, but a stand unattended might just as well not be there. I recall the time I was forced to leave a show for a whole day because of a previous commitment, and turned my stand over to a neighbor to attend during my absence. Although general sales were high the day I was gone, my sales plummeted to zero. I couldn't blame my neighbor because her concern was selling her work, not mine.

So much for "don'ts." Among the things to do are: get your socializing done before and after the show if you are alone, and keep your absences from your display as brief as possible; be friendly and helpful, and don't be afraid to smile—a dour countenance or spaced-out look will not lead to conversations or sales; let the customer know that you think him important by looking him in the eye when you speak to him; consider his time, and keep your conversation to the subject at hand.

SELLING AIDS

If your work is in the lower price range, you will probably never be asked to accept time payments. However, if your work sells for over $100, you may be asked if you will sell on time. Over half of the artists queried won't consider time payments, but the rest are not averse to this arrangement. Selling on time is the only way that certain sales can be made, and unless your work is in such demand that you don't need the sale, it can be a definite aid. If you anticipate any requests, you should have legal forms with you at the shows so that terms can be discussed and noted, to prevent future misunderstandings. As the customer is taking your work and leaving

you with only a down payment and a piece of paper, don't be embarrassed about asking to see a driver's license or credit document.

Occasionally I have sold on time or let work go out on a delayed-payment basis. I've never been taken for a dime, despite giving the customer ample opportunity. I've allowed customers to take a work home to try out, holding only their business cards as security. They have always bought and paid. I've mailed or shipped paintings and prints on request with no money in advance, and have yet to have anyone renege on payments; in fact, most people pay the shipping charge without my asking for it.

On one occasion a young customer expressed interest in a painting but didn't have the money in hand and wouldn't for two months. I told him to take the painting and send me a check whenever he could. I received his check within a week, with the explanation that, to justify my trust in him, he had borrowed money from his boss and girl friend. I'm not advocating this obviously slipshod way of doing business, but I find that people who buy art place special significance on their purchase; because of its importance to them, they aren't likely to rip off an artist.

This, I hasten to add, has been my own personal experience, and I'm sure there are other artists who do not share my trustfulness. It's always best to document your transaction officially in writing, so that you're covered in case the deal goes sour.

Accepting credit cards can be another aid to sales if your work costs more than the average person carries in cash. About 20 percent of the artists surveyed said they accept credit cards; 80 percent of them are pleased with the results, and only 20 percent expressed doubts. Those who use this system claimed that they make one-third of their sales using credit cards. They also mentioned that sales made this way are easier because customers don't think of a credit card as cash and are less likely to quibble over price.

If your prices are low and sales only average, the expense and bother of a credit system may not be worth the effort. However, if you accept the credit system, people will use it even if they have cash or personal checks with them. When I was dealing only in low-priced prints, ranging from $6 to $20, I rarely had requests to put a sale on a credit card; and people who made such requests usually agreed to pay cash. Now that my prices and my volume of sales have increased, I am giving serious thought to using a credit system; not using one cost me about $30 in sales in one recent show. Of the artists in the survey, an additional 20 percent were contemplating making the move to credit cards.

Many galleries offer their customers a guaranteed exchange. They stipulate that if the purchaser decides an acquisition was unwise, he or she

can, within a month's time, exchange it for a different one in the same or a higher price range. I have taken this one step farther. I volunteer to take back the work and refund the entire purchase price if at some unspecified future date the customer does not like his or her purchase. This eases the decision to purchase, and it shows that I am a person of integrity with faith in my product. Although I have made this offer countless times, only one couple has ever returned a painting. Because of my willingness to refund promptly, this couple has returned to view my work at subsequent shows, and although they haven't bought yet, I'm sure that they will at some future date. This move is not as foolhardy as it may at first seem. A print purchased six years ago for $20 would now be priced at $30, due to the increase in labor and material costs. If the edition of the returned print has been sold out, I can raise the price even higher because of its unavailability.

There are other aids used in marketing that I have not seen tried at art fairs. For instance, has anyone ever thought of offering a bonus with a sale? A silk-screen artist might do up some T-shirts with the legend "I bought a print from Joe Jones at the Mid States Art Festival" and give one away with each $25 purchase. I've seen potters wrap their wares in newspaper, and stuff them into brown paper bags. Has anyone thought of giving purchasers shopping bags with handles, and with the name of the pottery printed on them? How about offering free a print worth $6 with the sale of a $100 print? Would a free 10 percent discount coupon, offered in the local press the evening before a show, bring some lookers and buyers to your display? Or how about making your own "play money" to hand out to purchasers, who could use it as cash on some future sale? These suggestions may not be applicable to all artists but may work for some.

YOUR BEST SALES TECHNIQUE

You can determine what sales approach works best for you by analyzing a consummated sale, as well as attempted sales that didn't materialize. You have to feel natural and at home with your approach. I have heard other artists use sales pitches that made me cringe, but they obviously worked well for them.

I recall a number of years ago, sitting at a show where the customers were so few that you could count everyone on the street. A man came by with his son of about nine. As they were obviously out for a stroll and not seriously looking to buy, I dismissed them as sales prospects. The son started to flip through my portfolio, and, more to kill time than to press a sale, I engaged the child in conversation. When he mentioned, as a courtesy, that he liked my paintings, I told him they weren't paintings but

prints. When he inquired as to the process, I gave my usual five-sentence explanation. By this time the father had entered into the conversation, and he asked how I achieved a certain surface in my prints. I explained that the process was unique to me and briefly described how I went about achieving the particular effect. Then I flattered him by saying that not one person in a hundred was astute enough to notice this feature in my work, and that this extra effort generally went unrecognized. He said that as a dental technician, he was in a similar situation: if the dentures fit, the dentist got the credit; but if they didn't, the technician got the blame. I listened and sympathized. At the end of our conversation, he asked his son to pick his two favorites among the prints and then asked me to pick my favorite; he purchased all three for $90. After he left, I analyzed the sale and discovered that I had done a number of things right. I had engaged the primary prospect in conversation; I had involved the second party; I had flattered his astuteness; I had kept my explanations brief; and I had lent a sympathetic ear to the customer's personal problems. I had effectively, although not deliberately, turned a casual looker into a purchaser.

FOR OPENERS

If your work is of top quality, and if you have concerned yourself with its proper presentation and display, you have already taken the first steps to a sale. The work will, in many instances, sell itself without your involvement. I've had customers pause in front of my display and, without hesitating, state: "I'll take that one." In some instances, distracting a customer by engaging him in conversation when he is trying to make a decision may lose the sale. You must always be sensitive to the customer's needs. If he has the self-assurance to know what he wants, don't get in the way, but be ready to step in if you detect any wavering in his resolve to purchase.

Other customers lack self-assurance, and it is then your job to convince them that your product will fill their needs, and that your personal credentials are such that your work is worth the price you have placed on it.

If someone stops in front of your stand and examines your work, how do you involve him or her in conversation that will lead to a sale? I have a friend who tacks a sign across the top of her display, announcing: PAINTINGS BY MARCIA. Her opening line is "Hi, I'm Marcia!" If you are seated next to her at a show, you can go crazy hearing this announcement ten times an hour, but you must realize the customer hears it only once. By using this opener, Marcia has identified herself, and it is surprising how many people respond by introducing themselves. If they do so, she can repeat their names during the subsequent conversation, and people are flattered if you remember their names.

You might ask the viewer's opinion on a new work you are showing for the first time. If the judge has ticketed one of your works for final judging, call it to the customer's attention and ask his opinion on the judge's selection. Any question that will involve the viewer in your work is a good opener.

What you don't want to open with is a question that has nothing to do with you, your art, or the viewer's reason for being there. For instance, you don't want to say, "It's a beautiful day, isn't it?" In doing so, you have pulled the viewer's attention and thoughts away from your work. What ensues is a lengthy conversation regarding the possibility of rain or how bad the weather was at the show last year. With that kind of opener, you are allowing the potential customer to escape without making any decision regarding a purchase.

Those whose sales are high will tell you that a question requiring the customer to think before responding is one of the best openers. The question should not be answerable with "yes" or "no," should investigate the customer's desires, clarify his wishes, and get him thinking seriously about your work as a possible answer to the problem of what to buy. For a painter, the question might be, "Are you looking for a painting for yourself, or as a gift for someone?" If the customer answers that it is for himself, you might ask, "What room have you in mind for its display? . . . What are the colors in the room where you intend to hang it?" Then you can suggest, "I have a painting that should be what you are looking for. How does this appeal to you? . . . Then, how about this one, which uses your color scheme only as an accent in an otherwise all-white painting?" You are placing yourself in the position of helping the customer decide, and as most customers have sketchy art knowledge, your help will be welcome. If you're selling pottery, the questioning may go, "Are you looking for something utilitarian or ornamental? . . . The drinking goblets are over here—I also have this set in blue-green if you prefer a cooler color. . . . Which would you prefer? . . . Allow me to get out the other set so you can see it." If the customer expresses a desire to see the other set, he will probably buy one of the two offered, for in accommodating him you have also obligated him. These questions can be used when the customer is showing some hesitancy in making a selection, and will be needed in probably no more than 15 to 20 percent of your sales.

Many years ago, I had an acquaintance who operated a machine in a factory but hoped to become an auctioneer. He attended every possible auction and studied the techniques the auctioneers used. He then worked out his own spiel and practiced it for nine months by "crying sales" while he stood at his machine for eight hours a day. When the time came for him

to work at his first auction, he didn't have to think of what he was going to say because the words had become automatic. I'm suggesting that it's a good idea to write out questions to be asked and memorize them, so that you can recall and use them at the appropriate times. Having the proper questions come automatically alleviates any uneasy feeling that you are pushing for a sale.

If your display is well appointed, the majority of customers will concentrate on making a selection immediately. If they indicate either verbally or visually a preference for a certain work, don't confuse them by offering alternatives, but try to sell them their first choice. Don't bore them with a discourse on how the work was done unless they inquire as to the processes, and then keep it short. I have seen sales lost, and have lost too many myself, by an involved explanation of why I did the work, the processes involved, and my feelings about the work, when the information had not been requested. It's an easy trap to fall into because all artists love to talk about their work; but what you are doing, if your explanation is too long or technical, seems to be showing off your superiority in art knowledge, and you can thus incur the customer's resentment. Instead, ask questions that will allow him to express his opinion in a positive way, so that he can talk himself into the purchase. "What appeals to you about this print?" You might ask. Agree with his answer, and you've boosted his ego. Volunteer any reinforcing information, if it is the truth. You might say, "Your choice is a good one and shared by many others, as this has proven to be the most popular print in this particular series"; or, "This print has been selected by judges but hasn't had the sales I expected because not many people besides judges have your knowledge of what makes good art." Flattery will get you everywhere. By asking questions, encourage the customer to talk so that he may involve himself with your work, and perhaps air objections which you can overcome. If price is a factor, mention that you also have the print unframed at a lower figure and ask him, "Which would you prefer?" If he states a preference, he has committed himself. Without making a commitment of this sort, he is much less apt to buy.

Let me make a comparison. I have found that I do my best work when I "psych" myself up to paint. If I enter the studio with no plan of action, I am apt to dissipate the day by false starts and inconclusive decisions; I almost welcome minor distractions that can be solved easily. By solving the minor problems, I won't feel the day is entirely lost, but I will not have solved the major problem of completing the painting. If, however, I plan my moves before I enter the studio and have already made the decision that a certain section of a painting, or even the whole painting, must go, I never hesitate, but proceed at once toward a solution. I may or may not

like the solution, but I have at least moved ahead one step to a point where I can make another decision, which will eventually lead to the painting's completion. The same holds true for selling. I suggest that you plan a sales approach ahead of time, rehearse it, and then psych yourself into putting it into action. To be honest, if your sales haven't been terrific up to now, what have you got to lose by changing your approach?

THE CLOSING QUESTION

A number of years ago, I attended a symposium at a major Midwestern university where the topic of discussion was how to succeed as an artist. Three or four artists who had managed to arrange shows in minor New York galleries expounded on the proper approach to securing representation and the costs involved; the cost negated any profit, but they were willing to assume it in hope of eventual renown and success. The last speaker, a noted muralist whose work had received international recognition, and whose sales outstripped that of all the other speakers combined, got up and opened his talk by saying, "Selling your artwork is easier than you might think. All you have to do is ask somebody to buy it." Simple in concept? Yes, but he pursued his goal with as positive an attitude as I've ever seen. He had a large notebook filled with photographs of his major murals, which he showed to architects, builders, and owners-to-be of buildings. His personality and outgoing manner, coupled with this evidence of his proven ability, induced enough people to buy, although previously they hadn't given a thought to putting murals in their buildings, to keep him constantly busy. The point is that, despite his international reputation, he hadn't gotten so big that he hesitated to ask somebody to buy his work. Making contacts did not humiliate him. In fact, far from feeling that people were doing him a favor by purchasing his work, he felt that, by offering his murals, he was helping them to enhance their structures.

Involving the customer in a preliminary conversation isn't all that difficult, and most artists enjoy, or at least claim to enjoy, the customer contact; but at the last minute they freeze, having developed no effective way of putting the final question to the customer.

Some salespeople claim the closing of a sale should not come down to a final question; they say that the closing starts the minute you open your mouth, and that if you handle the sale properly, a positive decision is a certainty. This may be true sometimes, but there will always be customers whose indecisiveness can only be met by asking them to buy. I firmly believe some customers find the final question a relief, as it forces them to make a decision. The customer knows you're there to sell, and his stopping at your display indicates an interest in your work—more than a passing interest, if he engaged in a discussion about your product. Considering

this, I see no reason for being coy. Simply state, "I'd like to sell you this bowl, because from our conversation I believe it's what you are looking for." Or, "You can tell from our conversation that we're both high on this painting; won't you take it home?" Or still another approach, "I hope you are seriously considering the macramé, as I doubt that you will find anything on the street of this quality that can come as close to the size, color, and price you mentioned. Don't you agree?"

There, you've said it, you have asked the customer to buy your product; now wait for his answer. Whatever you do, don't attempt to elaborate on your final question, which may provide him with an escape from making the decision you want. When he came to the show he may not have thought of buying, but much art is bought on impulse, and with a proper sales technique, the casual looker can be turned into a buyer. He not only will buy but will also be thrilled with his purchase and count it his good fortune to have run across you. No one sells to everybody, but you are going to sell to more people if you ask them to purchase.

OVER-ACCOMMODATION COSTS MONEY

Part of a successful sales program is to recognize which of your customers are seriously committed, which are potential, and which will take up your time in idle conversation without any intention of buying anything. Earlier on I mentioned one of the more difficult sales to make, where a husband and wife are at odds not only about a choice of purchase, but about buying anything at all. When you hit an obvious impasse, don't hesitate to let the indecisive customer go. To spend time with someone who is just too reluctant to commit himself can be a pure waste. Your time will be better employed with real or potential customers.

I have worked for twenty minutes trying to convince someone to purchase a $6.00 print, meanwhile losing five other parties who had lingered but then walked on because I failed to pay attention to them. Never be afraid to interrupt a discussion with one customer to acknowledge a second. Be polite, but try not to ignore anyone. You have just so much time to devote to a customer, and if he hesitates too long or gives you the "I'll be back" escape line, let him go. At the average show there are hundreds of potential customers walking by you every hour. This is where street selling differs from store selling, because you will be brought into contact with more people in an hour on the street than you'll see in a day or even a week of store selling.

HOW BADLY DO YOU WANT SUCCESS?

I'm sure that some of what I've been writing about is not new to you, and that, whether deliberately or accidentally, you may have been using some

of my suggestions. Selling isn't luck, for if it were, you would be getting your statistical share. To improve, concentrate on your sales and analyze your successes and failures. Frequently, fortune will place you next to some artists who have developed a successful sales technique; listen to them and learn. Read books on sales techniques; although they may not deal specifically with art sales, many of the methods used to sell real estate or cars can be modified to your needs. There is an old adage in the fight game that the hungry fighter is the one who will drive himself to success. As an artist you've got to have goals, and if your goal is financial success, you must dedicate all your time and effort to turning out a marketing product, presenting that product to the best of your ability, and developing a sales program and the ability to implement it. If you ignore any of these three requirements for success, you will remain only average.

12

FURTHER ADVICE

As the art scene changes continually, I have already noted shifts from the survey's findings, which I've tried to take into account in this book. The status of shows, however hasn't changed much since the survey was made, despite major economic fluctuations. This stability has made me optimistic about the future of art fairs.

THE CHANGING ART SCENE

Twenty years ago, when the public was still high on European art, any painting that included the Eiffel Tower had a ready sale. As I haven't seen a painting of this type in the past fifteen years, I assume its appeal has evaporated. Art changes constantly, images change, and acceptable colors change; as a consequence, you must keep an eye on the marketplace if you want to continue to sell. Changes usually are not rapid, and last year's images may sell this year and the next as well, but at a diminishing rate. You must stay attuned to what is happening if you want to hit the top and stay there.

Fortunately, help is available. Most artists I know, myself included, are subject to the influence of others. We learn and improve by borrowing. I don't know how a painter can't be influenced by the compositions of Vermeer and Robert Rauschenberg, the paint fluidity of Richard Diebenkorn and Willem de Kooning, or the value changes in a Rembrandt. I rarely attend an art show or read a current art publication without being struck by a few of the artists' treatments; and I seriously consider adding some of their techniques to my painting vocabulary. Visits to department and furniture stores will let you know what the public is buying. Have yourself put on the mailing lists of art-publication houses as well as retail mail-order catalogues. You may not have the time, inclination, or know-how to do marketing research. These companies have, so avail yourself of the results of their research. But, you may ask, isn't that stealing? If you copy directly, it is, and there are penalties for copyright infringements. What you must do is make variations in what you borrow. If you admire a ceramic depiction of a dog, and believe it might be marketable, you can turn out a raccoon in the same technique. If it's a landscape painting, find another scene and do it using the colors and techniques of the one you fancy.

I have two cardboard boxes in my studio. In one I have clippings of techniques I have found interesting; and although I'd have to live to be a thousand to utilize everything in that box, I do find it a ready inspirational source, and a help in solving numerous problems. In the other box I keep clippings of subject matter that can be used in my art. It saves me countless trips to the library to check out books on birds, boats, and barracudas. By now you are probably wondering if I'm without scruples. Definitely! I make it a point never to borrow from a fellow art-fair artist; that could lead not only to embarrassment but a bloodied face or mangled appendages.

THE PRESENT STATUS OF SHOWS

The survey questions about present conditions in art shows evoked much comment. The majority of the respondents favor shows that are open to all artists regardless of place of residence. They feel quality can be maintained only by inviting everyone and then submitting all work to a tough screening. They believe that to open shows only to local artists will reduce the quality of any show. They hold to the survival of the fittest and claim that the only way to raise the level of audience tastes is to eliminate bad art. If screening committees took their work seriously, there would be no place for the junk peddlers that infiltrate many shows. The professional artist who has spent time and money learning his craft is opposed to those who acquire their questionable skills in three weeks, and turn out a poor-quality product that caters to the lowest level of public taste. They feel that allowing this element into shows not only hurts serious artists financially, but hurts art as well. Good artists, confident of their abilities, want better competition, not worse.

One-fifth of the artists favor more major shows, and only 10 percent feel that the show scene is saturated. There were a few remarks to the effect that mall shows may be overdone, as one single mall may have as many as five shows a year. Many are bothered by the infiltration of wholesalers into their marketplace, particularly in some malls, and are irate over the "Hungry Artist" gimmick in which a dealer rents space at a motel and runs a highly concentrated promotional campaign to sell bad imported European art.

What do artists think is the ideal show? The ideal show would feature 200 quality artists or less. It would distribute space among the media fairly, and in such a way that no medium would be placed next to a similar one. Spaces would be adequate, with electrical outlets in case the show ran into the twilight hours. No outside entertainment would be allowed. Free coffee and donuts would be furnished to the artists, and an artist's bash

would be held one evening. Assistance would be given in unloading and loading, with on-site overnight storage and security. Staff would be on hand to relieve you in sitting at your display for brief periods of time. The show committee would police the show to remove squatters and also artists who display work of lower quality than the slides that gained them entrance to the show. Advance publicity would bring the public out in force, and as a result, sales would be phenomenal. A dream? Two major shows I attended last year met practically all of these criteria, and I only hope the committees of less prestigious shows were there to see what was possible. I might also add that I attended a few shows where not one of these ideal conditions was met. At one show, I stayed at a motel only two blocks from the show site, and not one person at the motel knew a show was in progress.

THE FUTURE OF ART FAIRS

Changes in the economy always have had, and will continue to have, an effect on the art business. The artists who survive will be the ones who assess the problems correctly and adjust to anticipated changes. There is always a fear of the unknown, which can lead to panic. Before you sell your van, display, and raw materials, I want to state my conviction—based on reading, discussions with other artists, and personal assessment—that art fairs will not only survive but continue to grow.

Here is how I arrived at this conclusion. Unemployment, one of the first indicators of economic trouble, will have no immediate effect on art sales. Many of the unemployed lack skills or education and are not purchasers of art. You can't lose a customer who never existed. Gas rationing, should it come, may limit the artist's ability to travel great distances, but it should increase the turnout of customers at area shows because they will be seeking activities and amusements close to home. Promoters, whether individuals or organizations, recognize the profit potential in running art shows, and they won't cease activity until artists stop renting spaces. If anything, art shows will continue to increase in number. Since we are turning out more artists every year who will be seeking a marketplace for their wares, artists will continue to patronize art fairs as long as they are profitable. They will become unprofitable only when people stop buying, which may coincide with the next ice age.

The large majority of the art-buying public today has never seen a soup kitchen or a bread line, and let's hope they never do. They know only the postwar prosperity and affluence. They and their offspring are not given to self-denial, and in their optimism will continue to spend without concern. They will provide for necessities first but won't hesitate to spend on the

things that will maintain or improve their quality of life. This portends well for art and the artist.

As the dollar decreases in value, people are looking for investments that will hold their value. The customer who buys a silver or gold ring is buying more than an art object; he or she is purchasing a commodity which will increase in intrinsic as well as artistic value. Investing in art has always been a hedge against inflation, and auction houses are selling the paintings of little-known nineteenth-century artists at substantial figures. The average person can't afford to buy at that level, nor does he have the means to purchase the blue-chip works of America's nationally known living artists. He is thus forced to buy at the level he can afford, which is from the art-fair artists.

This may seem to be a grandiose assumption, but it is not. I know art-fair artists whose work has tripled in price in the past six years. In purchasing art as an investment, the purchaser should know art or rely on the advice of someone who does. Had I the means, I would purchase the works of two or three of the top prize-winners at most major shows, feeling confident my investment was a wise one and would appreciate with time.

When people seek art investment, they look for original art. Many art dealers who in the past handled only offset prints are now seeking artists to furnish them with editioned prints, hand pulled by the artist. Why? Because their outlets and the customers of those outlets have awakened to the fact that original art is an investment that appreciates and is worth more than the paper on which it is printed. Good art can only be helped by a recession, but bad art will suffer. Quality will survive.